Andy Lakey: Art, Angels, and Miracles

Andy Lakey: Art, Angels, and Miracles

Andy Lakey and Paul Robert Walker
Foreword by James Redfield

Turner Publishing, Inc.

ATLANTA

To my wife, Chantal, and my girls: Joy, Cora, and Giovanna.
–A. L.

To my earthly angels: Marlene, Devin, and Dariel.
–P. R. W.

Copyright ©1996 by Andy Lakey and Paul Robert Walker
Foreword copyright © 1996 by James Redfield

"Angels in Life and Death" appeared in somewhat different form in *Every Day's a Miracle*, by Paul Robert Walker. Published by Avon Books, 1995.
"Kindred Spirits" Copyright © 1996 by Betty J. Eadie.
"The Source of Genius" adapted from *Humor and the Hereafter: A New Philosophy of the Paranormal.* Copyright © 1996 by Raymond A. Moody Jr., M.D.

Library of Congress Cataloging-in-Publication Data
Lakey, Andy, 1959–
Andy Lakey: art, angels, and miracles/by Andy Lakey and Paul Robert Walker; foreword by James Redfield

p. cm.
ISBN 1-57036-282-3
1. Lakey, Andy, 1959– . 2. Painters—United States—Biography. 3. Angels in art. I. Walker, Paul Robert. II. Title.
ND237.L238A2 1996
759.13—dc20
[B] 95-45971
 CIP

Published by Turner Publishing, Inc.
A Subsidiary of Turner Broadcasting System, Inc.
1050 Techwood Drive, NW
Atlanta, Georgia 30318

Distributed by Andrews and McMeel
A Universal Press Syndicate Company
4900 Main Street
Kansas City, Missouri 64112

First Edition
10 9 8 7 6 5 4 3 2 1

Printed in the U.S.A.

Contents

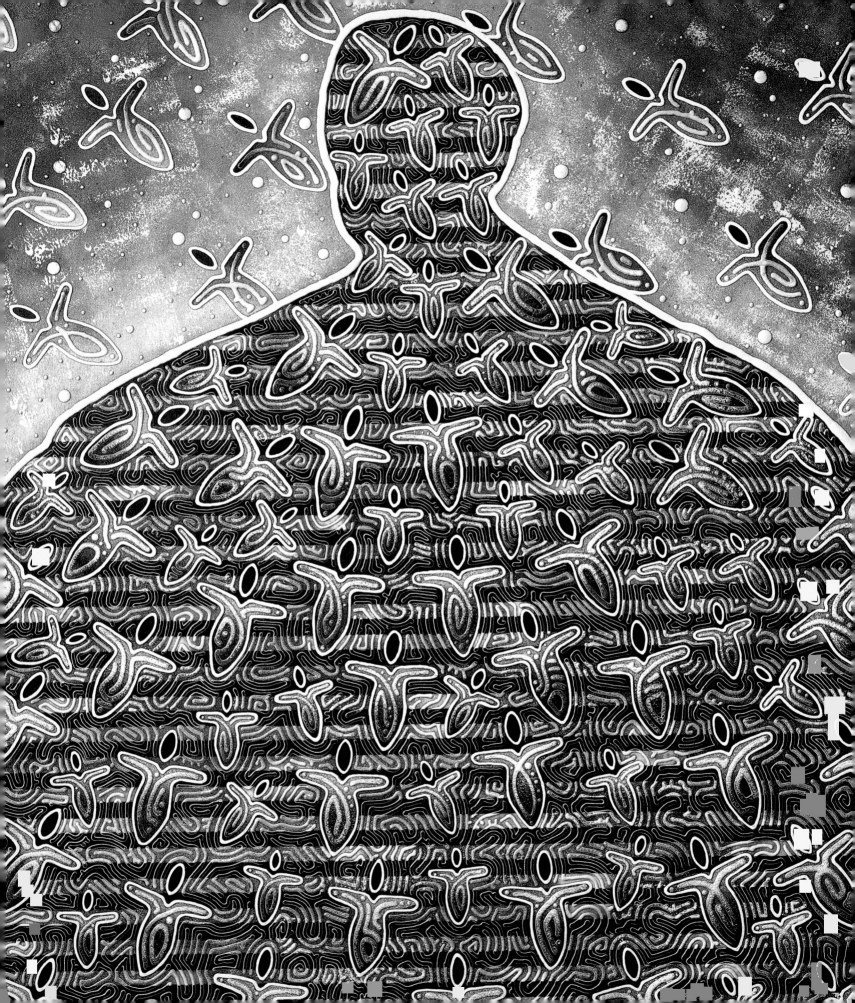

I never thought much about art, angels, or miracles until I met my own angels during a near-death experience on New Year's Eve 1986. Since then, these wondrous powers have become an infinite, interwoven thread that carries me through every moment of every day as I explore the new life I have been granted. I know angels are real, because I've seen them and experienced their unconditional love. I know that miracles happen, because I've witnessed them in my own life and the lives of others. And for me personally, the most awesome miracle is the gift of artistic expression that I received and have continued to develop under the guidance of my angels. Many others before me have witnessed the angelic realm, either during close brushes with death or during other mystical experiences. Yet though we try to describe what we have seen and felt, words cannot convey the power, love, and light of the other dimension. Perhaps that's why I was given the gift of art—so that I could bring heavenly images to the earth. Of course, a painting is only a pale reflection of the true celestial splendor, but to the best of my ability, I try to express what I have seen. My own development as an artist has given me a greater appreciation for the power and importance of all the arts, not only painting and sculpture, but music, literature, theater, dance, film, photography—all the ways that human beings express their vision of the world. We live in a complex and often confusing time, a time when the arts are not only needed, but vital. It is through the arts that people young and old discover the connection that flows within all of us. We all love, struggle, enjoy relationships, and search for meaning. No other experience can match the power of the arts in reflecting our humanity and common bond. Although images are my form of expression, words have great power, too. The first time I met Paul Robert Walker, I knew we would write this book together. Paul has a unique way of listening to me and expressing the way I feel, just the way I would express it myself, if I were a writer. I am honored to have my life and work profiled in a book. Yet, I believe that every one of us has a special story, because we are all partners in the great human adventure. More than that, I believe we are part of a larger, cosmic adventure that echoes across the universe. We each play our own role, we each have our own mission, according to the gifts that we are given, but none of us can achieve our goals without the help of others. For now, at least, my mission is to create 2,000 angel paintings by the year 2000. I hope with all my heart that my mission helps you, in some small way, to walk your path in light and love.

A Letter to the Reader - Andy Lakey

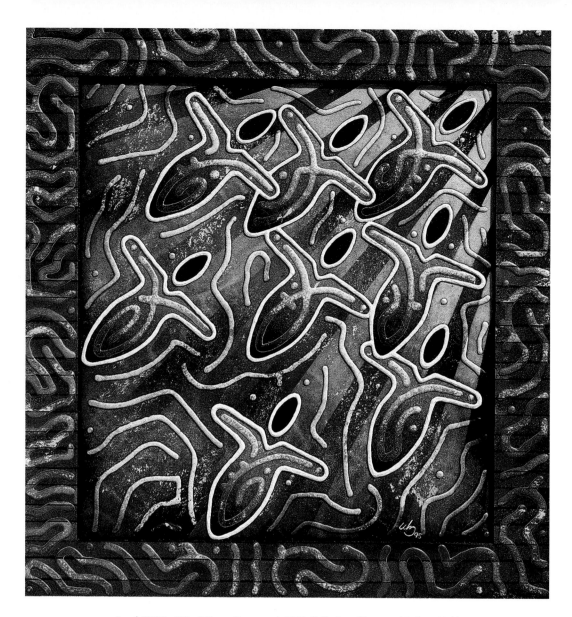

Angel #1323, *28" x 30", acrylic on wood, 1995. Collection of James and Salle Redfield.*

I first heard of Andy Lakey during a conversation with a group of aspiring artists outside a Unity Church in Miami, Florida. As I walked up, they were marveling over the almost instant success of a young man from California, who, as it turned out, had announced one day that he was quitting his job to become a painter, although he had no formal training as an artist. Amazingly, he had pulled it off. His paintings were now selling for thousands of dollars, and he had gallery opportunities all over the world. As they discussed the story, rather than envy, what the Miami artists seemed to be feeling was a sense of newly found inspiration. ¶ "What does Andy paint?" I asked. ¶ They stared at me in silence. "I thought you knew," one of them said, "he paints angels." ¶ Later, of course, I found out there was much more to the story. Andy Lakey had been living a roller-coaster adventure that had taken him from the lowest depths of drug use to spiritual experiences of the highest order, an adventure that will be presented—along with his stunning paintings—in the following sections of this book. You see, Andy does not just paint angels, he has traveled to the edge of death and been visited by them, which is perhaps the most stirring part of this whole saga. ¶ Right now, the world is absolutely enthralled with these celestial beings—and not in an abstract way, as in the past, when we considered angels cute representations of religious history. We're interested in them now as real, living entities. We seem to know that they truly exist, and we expect to actually see them, like Andy, and to experience their energy and intervention. ¶ This shift in attitude about angels, I think, reveals just how much Western culture has changed in the past thirty years. For centuries, we in the West have labored under what could only be called a secular trance, believing that science had succeeded in locating and defining all the really important phenomena in the universe, and acting as though the mysteries associated with

Foreword by James Redfield

existence had all been reduced to intellectualized religious beliefs and to the mechanics of personal economic survival. As we found out, of course, this collective illusion that the universe was explained was built on a tacit agreement among scientists and other thinkers to systematically exclude from investigation any phenomena that might threaten that presumption. ¶ The result was that a rich and diverse part of the perceptible universe was almost totally disregarded. Throughout history, for instance, humans have had near-death experiences (including meetings with various dimensional entities), psychic visions of the future and the past, transformational ecstatic states (of both the "nirvana" and the "born again" variety), received positive results from prayer and visualization, and experienced a rich assortment of other phenomena—one of the most important of which has been the sighting of angels. ¶ Unfortunately, from the beginning, coming out and admitting any of these experiences has often brought about some rather unpleasant reactions. In medieval time, for example, depending upon whom one told, the confession could either make one a saint or get one burned at the stake. In later centuries, such spiritual honesty has merely brought on ostracism and ridicule, and, as we've seen, the condemnation of science. ¶ Yet all that began to shift in the 1960s, when a wave of philosophical heroes began to tackle our self-imposed repression. In a move to make scientists more historically reflective, philosopher-historian Thomas Kuhn exposed the tendency of science to operate only within fashionable paradigms. Philosophers Ernest Becker and Norman O. Brown showed how societies often fight off the anxiety of life by repressing and even making taboo any mention of life's greatest mysteries. And later, through the seventies and eighties, a mass of interest in Perennial Philosophy, Eastern Religion, and the Human Potential Movement finally blew the lid off our cultural illusion for good. ¶ Now, in most circles, one can be honest and vocal about one's experiences, no matter how unusual these perceptions may be, which has initiated a wide discourse on the spiritual nature of this human life we are living. The consensus

seems to be that we exist in a universe replete with miracles and spiritual wonders, and that once we get clear of the repression and pretension that has so long plagued our society, each of us can open up to our own liberating connection to the divine. ¶ What's more, when we discover this connection, a constant stream of self-clarifying revelations begins to enter our awareness. First, we begin to understand that the circumstances of our individual lives have special meaning. It is no accident that we are where we are in life, doing what we are doing, preparing, as it were, to go on to what's next. And second, a complete review of our lives reveals that everything that has happened to us, the initial placement with our early family, the synchronistic twists and turns, have all been a preparation for what we can now discern to be our special contribution to the world. ¶ Once these revelations have been received, there is no way to close one's eyes and succumb again to the old trance. We know that the human experience at its most open is a dramatic spiritual experience. Responding to the strength of our expectation, the world opens up for us in a grand adventure of guiding intuitions, unbelievable coincidences, and magic interactions with just the right person at just the right time. ¶ Such fascinating adventure is now the new standard for the good life, and we're constantly on the lookout for the next turn in the plot and the next crossing with another individual who seems to be doing the same thing, validating that we're on the right track. ¶ Which, I think, is why Andy's story is spreading so quickly across the world: he has taken the experience of inspiration to new heights. Since his visitation by angels, almost every door has opened so that he could paint his paintings, touch the lives of thousands of people, and work toward his special mission in the world. ¶ When we hear about the miraculous life of Andy Lakey, sense his adventure unfolding, and feel the awesome presence of his paintings, we are deeply moved inside. Like my artist friends in Miami, we are imbued with a newly found sense of possibility and wonder. Andy Lakey has found his path with the angels . . . and we know that we can find ours, too.

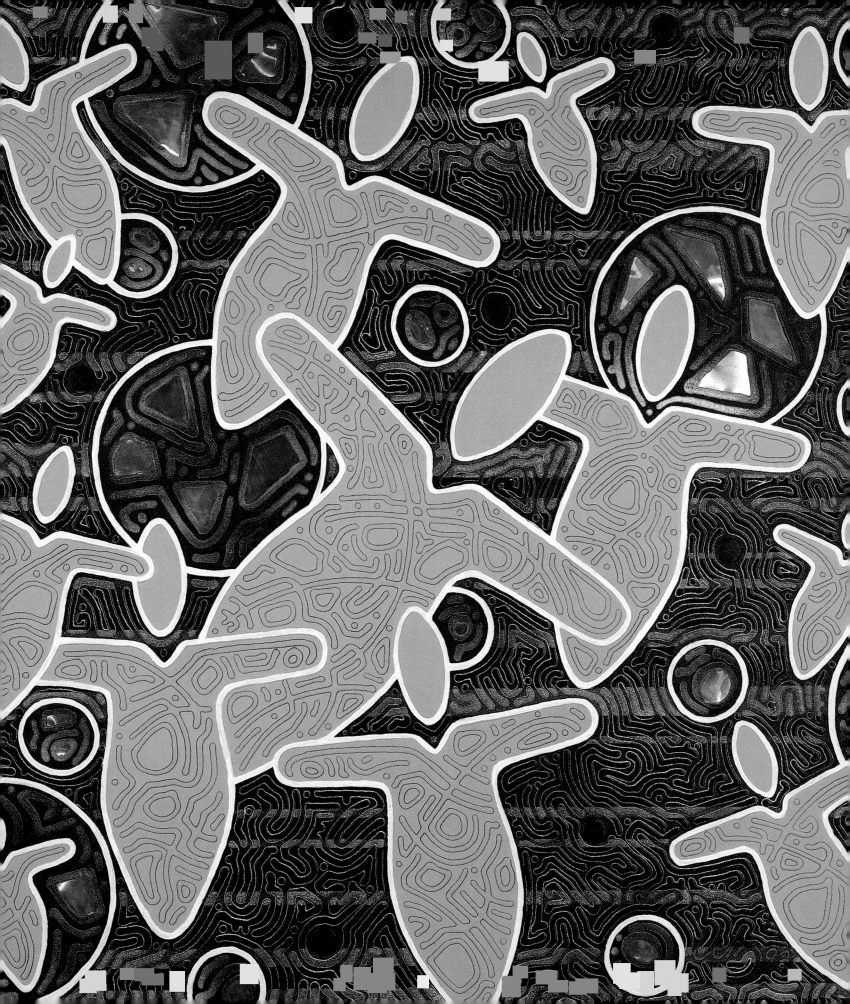

Andy Lakey: Art, Angels, and Miracles

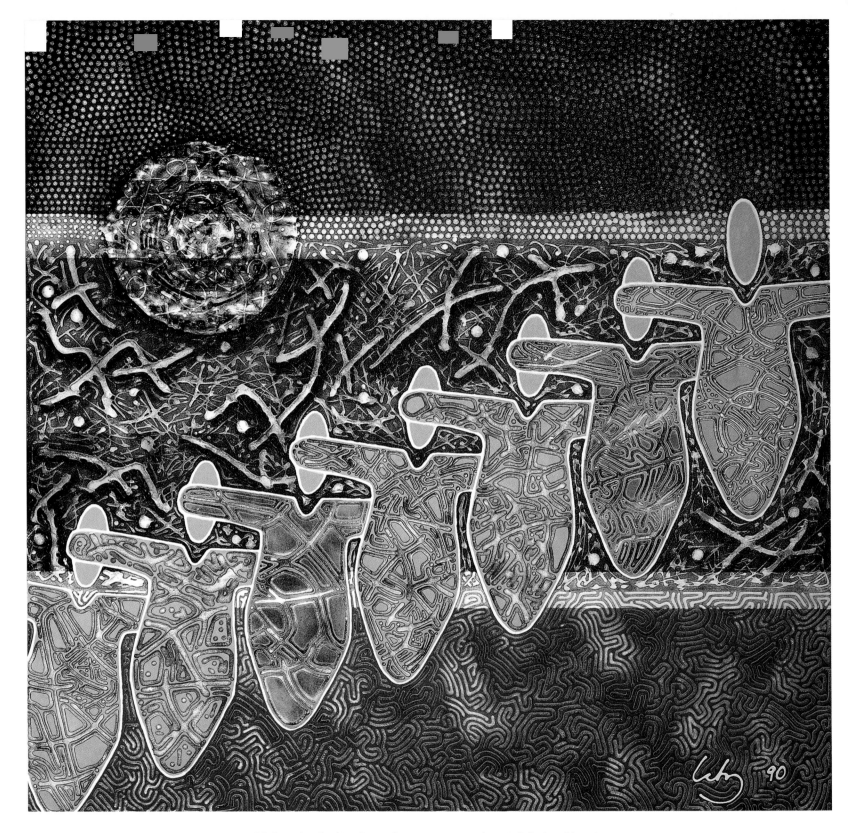

My Seven Angels, *48″ x 48″, acrylic on canvas over wood, 1990. Collection of the artist.*

Andy Lakey's angels fly without wings—pure, powerful forms rising gracefully toward the light. So different from traditional angel art, yet strangely familiar, his images reach out, inviting touch and love and wonder. Some say they heal and speak. A few talk of miracles. This much is certain: Lakey's angels remind us who we really are—beings of energy, light, and goodness, who soar on the waves of eternity. ❖ Today, only six years after he began to paint, Andy Lakey's angels are displayed in museums and treasured by collectors around the globe, from the pope, presidents, and movie stars to eleven-year-old Matthew Tash, who heard a Lakey angel on a hospital wall offer words of comfort as he prepared for surgery. Matthew's story is not unusual; many Lakey collectors have reported extraordinary experiences with his angel paintings. Some claim no more than peace and well-being; others appreciate the paintings primarily as imaginative and aesthetically stimulating art. Whatever the personal response, Andy Lakey's angels are one of the fastest-growing art forms in the history of popular culture. ❖ Many artists struggle for decades—or a lifetime—before achieving recognition and success. Andy Lakey, an artist with no formal training, has sold over one thousand paintings and hundreds of sketches in only six years. He's made scores of appearances on national television and radio, been profiled in newspapers and magazines, and his art has been showcased in an angel encyclopedia. Lakey is the first painter to hold a showing for the blind, the first artist whose paintings are used by professional healers, and the first modern artist to work within the Great Pyramid, tapping into an ancient source of energy and power. He is a spiritual-artistic phenomenon. ❖ What is the source of this popular and prolific creative output? Art experts praise Lakey's raised, tactile textures, a unique style that has been labeled Sensualism. They point to his strong sense of line and fine eye for color and design. Others credit the growing fascination with angels and life-after-death as we approach the mystical, millennial year 2000. All these factors may come into

CHAPTER ONE

Seven Angels

play; yet the artist himself sees something far more remarkable at work: Andy Lakey believes the real source of his artistic power comes straight from the angels. ¶ "Every morning, I wake up and thank God for the hands to paint," he says, "and the power He placed in them. I know that I was saved by the angels for a special mission on this earth, and my hands, my paintings, are the medium of that mission." ¶ "Saved" is a key word in Lakey's view of his life and work. He's convinced that without angelic intervention he would have died before creating a single painting. Until New Year's Eve 1986, when he came face-to-face with his angels, Andy Lakey was lost in a self-destructive and dangerous lifestyle, riding a drug-fueled roller coaster on a wild dash to disaster. ¶ Many artists have a self-destructive streak; perhaps it serves to balance the powerful creative urge. For Andy Lakey, however, there was something else at work, a lack of purpose, a lack of place. Born in France in 1959 to a Spanish-French teenage mother and a not-much-older American airman, he was caught between cultures, half-European, half-American. He bounced around the world with his mother and stepfather, another American airman who moved the family from France to Ohio and Japan, from Japan to Kansas and California. Looking for acceptance, Lakey smoked marijuana in junior high and experimented with cocaine in high school; his drug use escalated during a stint in the Navy, where he ended up on a rust bucket full of misfits as lost and wild as he was. Along with thousands of other drug users in the military, Lakey took an early honorable discharge under a special program titled Project Upgrade, but though he cut his ties with the Navy, he continued on his downward spiral. ¶ Unlike many users, however, Lakey never let the drugs interfere with his work. Affable and outgoing, he was a skilled salesman who worked harder than everyone else so he'd have enough money to buy drugs, especially the high-quality cocaine that he smoked in potent free-base form. By 1986, at the age of twenty-seven, he was earning $85,000 a year as a top car salesman—impressive by any standards. Except for a car, some clothes, and a small, rented apartment, however, he had nothing to show for it. Everything he earned went to drugs and parties for himself and his friends. He didn't even bother to pay his income tax. Then on New Year's Eve, the party came to a crashing, swirling halt. ¶ "We were at a friend's apartment upstairs from my own," Lakey recalls. "The funny thing is that on this particular night I didn't really do any more drugs than usual; in fact there were plenty of times in the past when I'd done a lot more—times I free based for twenty straight hours, and after all the rocks were gone I would look on the floor and

Angel #1372, Self-portrait #3, 5" x 7", acrylic on wood, 1995. Collection of Nancy Benstead.

ANDY LAKEY: ART, ANGELS, AND MIRACLES

16

Blue Man Waiting for Angels, *18 1/2" x 22", acrylic on masonite, 1992. Collection of Jerry and Sho Simon.*

try to smoke the little white balls that fell from the acoustic ceiling. It was sick, terrible. But on this particular night it was New Year's Eve, and we were just having a good time. I did a little drinking, I hit the free-base pipe, I did some snorting, and all of a sudden it felt like my heart was beating a million beats a second. I was freaking out. I knew I was going to die." ¶ A natural response would have been to call 911 to ask for help. But through all his years of drug use, Lakey had never asked for help and he wasn't about to start. Strangely enough, while he believed he was dying, he was too embarrassed to admit he was having a problem. So he became an actor, rising to his feet and blurting out, "Hey, I'll see you guys tomorrow." He managed to walk out the door, only to collapse in the hallway and stumble down the stairs to his own apartment. "I was scared," he remembers, "really, really scared. I didn't know what was going to happen. I didn't know if my head was going to explode or if I was going to fall flat on my face." ¶ Leaving his door open, Lakey dragged himself into the kitchen and put a can of soup on the stove. He doesn't remember why he did it or if he ever lit the flame. Perhaps he felt he needed nourishment. As it turned out, the nourishment he needed didn't come from food: "Suddenly I made a beeline straight for the shower, at least as straight as I could. I didn't know it at the time, but it was the angels talking to me; God, the angels, wanted me in water. I pulled myself into the shower and turned on the ice cold water. The first thing I remember is putting water on my face and opening the front of my shirt and letting water go down my chest. Then I turned around and put my head against the wall, put my head down and prayed to God for the first time since I was a kid. I prayed to God to take me to heaven. I knew I was going to die, and if it was true what I learned when I was a child—that if you sin, you do drugs, you do all those things, you go to hell—then I wanted to make sure I went to heaven. So I prayed to God to forgive me all my sins. I still remember the prayer. I said, 'God is good. God is great. . . . God, if you let me live, I will never do drugs again, and I will do something to help humankind.'" ¶ Andy Lakey was not the first person to plead with God in the face of death; nor was he the first to have his prayers answered. There are no atheists in a foxhole, it is said, and on that New Year's Eve, the ice cold shower was Andy Lakey's foxhole. But as often happens in contracts between heaven and earth, the dying car salesman got more than he bargained for. Much more. For the answer to Lakey's prayer was something even greater than life, something beyond a second chance. It was a direct glimpse of the spiritual world, the inner workings of the universe, an epiphany that began in the loving

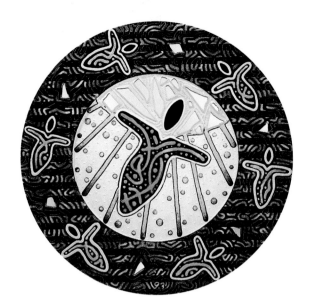

Angel #502, *38" round,*
mixed media on wood, 1993.

Angel #840, *60" x 72",*
mixed media on canvas over wood, 1994.
Collection of the artist.

embrace of his angels. "I felt a twirling sensation, like a little tornado or whirlpool around my feet. I didn't see them in detail, but I knew there were seven figures, and as they twirled up toward my knees, my thighs, my waist and up to my chest, the twirling got faster and faster. It was like a whirlwind, but I was standing still, and I saw the water splattering around me. ¶ When they reached my heart, they came together as one and put their arms around me, or maybe I should say *its* arms around me, because now there was only one figure—exactly like the figures you see in my paintings. It had a tapered body with stublike arms, and a featureless head elevated above the body. It put its arms around me and I felt a wonderful, warm rush of unconditional love as it lifted me into another dimension. ¶ There were a thousand planets with ten thousand poles of light extending through them and into the void. Every pole and planet interacted with the others; every pole pierced other poles and planets, like a galaxy of brightness in cellophane and iridescent colors: each planet was like a baseball with an infinite straw inserted all the way through the ball. Where the pole touched another planet it was so bright that I couldn't see, but I could tell that the poles continued in both directions. I call them the telephone poles of light, because from my perspective at the time, they seemed the size of a telephone pole—if a telephone pole went on forever. It was incredibly bright up close, but where there were no poles or planets, there was darkness, blackness, pitch black, creating incredible contrast. That's why you see a lot of black in my paintings, that's what I'm guided to paint. ¶ Now imagine all the poles working

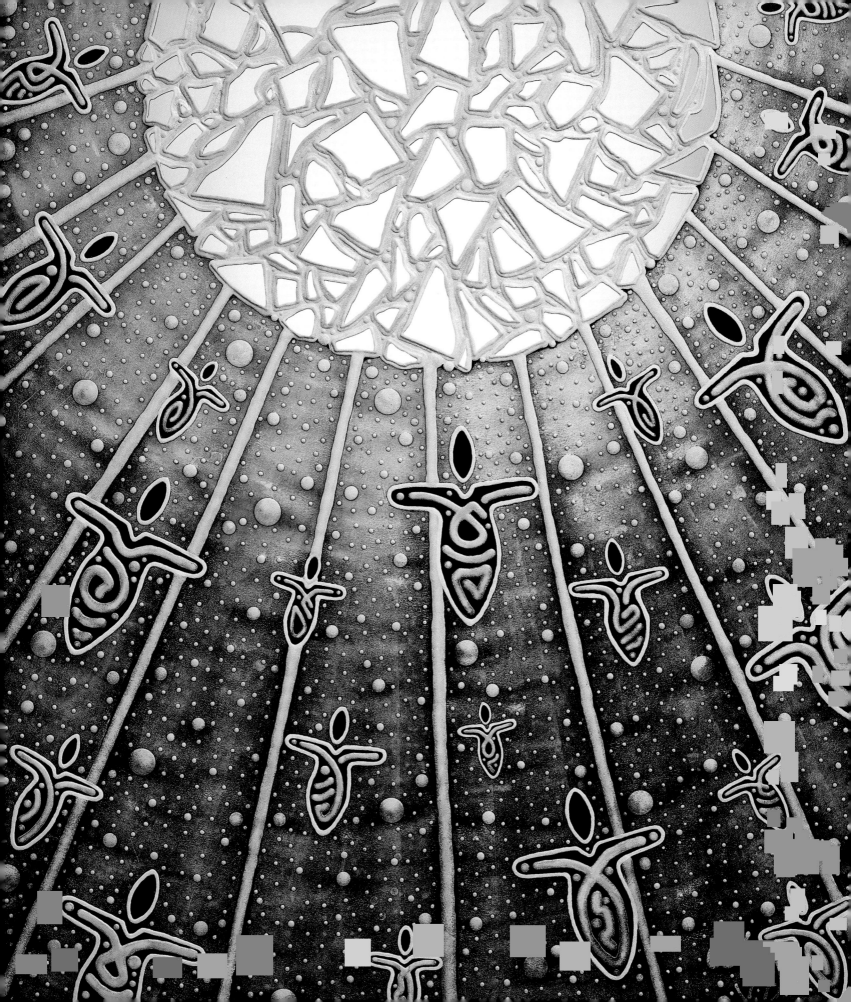

Angel #888, 48″ x 36″, acrylic on wood, 1994. Collection of the artist.

together, ten thousand of them, and inside each pole were millions of tiny figures, with thousands of others—including me—waiting to enter. All the figures, the angels, were the same size. Their faces were featureless, like the seven angels spinning around me in the shower, and they each had different insignia-like markings on their back or chest area. These markings looked almost like a coat of arms, except the lines that created them were writhing, organic forms. The figures floated in single file, in all these poles on all these planets, like a movie theater with everybody in line waiting to get in. Every pole was filled with millions of souls in perfect columns and perfect harmony. But I could not get into a pole. ¶ I didn't notice anyone else who was unable to get in. They just entered the poles naturally and moved into the line. I wanted to do the same. I lunged forward like a dive bomber, trying to get in, but I hit the outside wall of the pole and bounced away. Then I dove toward another pole. And another. And another. But I couldn't get in. I felt—I don't know—I guess I felt sad. I just wanted in, and I was rejected, bounced off the poles and out of the dimension. ¶ I woke up in the emergency room of a ReadiCare Center. My throat was painfully sore, and I had an IV in both arms. There was a doctor working over me. I felt very groggy; they asked me

Angel #959, 54″ x 36″, mixed media on wood, 1994. Collection of Fran Clark.

what kind of drugs I was doing, but I was incoherent. I remember throwing up. And they asked me if I was ready to go to the hospital." ¶ Later, Lakey pieced together what had happened while he made his cosmic journey. His friend in the upstairs apartment—the host of the New Year's Eve party—had become concerned and decided to go downstairs and check on him. Finding the door wide open, he walked in and discovered Andy lying rigid in the shower, the cold water pounding down on his body. He called for help from others at the party, and they carried him outside and laid him in the back of a pickup truck. As they sped down the street, a police car fell in behind the truck and followed them to the ReadiCare Center, where the medical staff pumped his stomach and gave him intravenous fluids. ¶ Once he was stabilized, Lakey was sent to a nearby hospital for further evaluation. There the doctor explained that he had enough cocaine in his body to kill him, that his heart was failing, and that the ReadiCare staff had saved his life. Despite his years of drug abuse, Lakey had a strong constitution, and once he regained consciousness, his vital signs quickly returned to normal. He was released from the hospital after two days and sent home to get on with his life, a life that would never again be the same. ¶ Andy Lakey made an agreement with

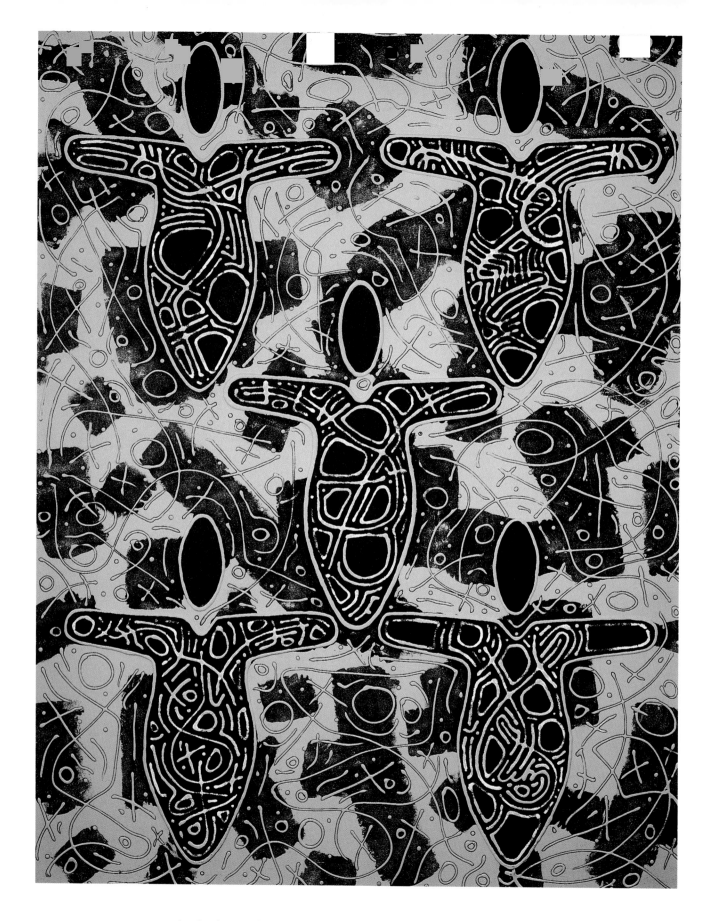

Angel #347, 36" x 48", acrylic on canvas over wood, 1991. Collection of Wendy Merchant.

"I get a complete sense of peace and a tremendous amount of love from Andy's angels. They help me to realize that what we go through on a daily basis is so insignificant; and that when you look at the overall picture, and what is ahead of us, that is much more important.... This man has so much to give to the world. He is doing so much for people with his paintings, giving them a whole different outlook on life."

ANNE FELLMER
COLLECTOR
MISSION VIEJO, CALIFORNIA
AUGUST 1995

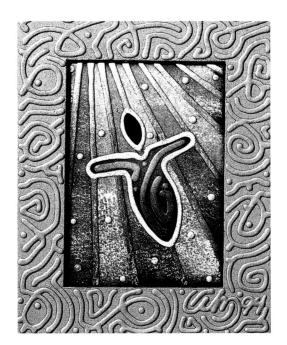

Angel #878, *16″ x 20″, acrylic on wood, 1994.*

SEVEN ANGELS

God, and he intended to keep it. Perhaps that's the real key to his success. Many have prayed in the face of death or danger only to forget their prayers when the crisis has passed. Lakey didn't forget. He never touched drugs again, and when he returned to work, he realized that he needed to find a new job. Too many of his fellow car salesmen had been his partners in partying; so he found a job at another car dealership where drug use was less prevalent. Later he moved to another apartment to get farther away from his drug-using friends and neighbors. Though overjoyed at being alive, it was a difficult transition, a time of loneliness and soul-searching. ¶ "I had no friends," he remembers. "All my old friends were still doing drugs. I'd never been really close with my family, so my friends were always like my family. Now I had nobody to turn to, and I felt like life had just slapped me in the face—like everyone else in the world was ahead of me, and I was never going to catch up." ¶ Yet, Lakey knew that his very being had been changed for the better. "I never felt much love as a child," he admits, "and I had trouble giving and expressing love to others. The warm, overflowing rush of unconditional love that I felt from the angels changed that. I still had a long way to go and many lessons to learn, but as soon as I recovered from the overdose, I looked at the world and at other people with new eyes. I felt love for others . . . compassion . . . and I really wanted to keep my promises to God, not just the first promise to stay off drugs, but the second promise, to give something back to humankind." ¶ Although he'd never been much of a reader, Lakey began reading motivational books, looking for guidance in putting his life back on track. He picked up bits and pieces of various philosophies, but the essential message he absorbed was the tried-and-true power of positive thinking. To be successful, you must act successful and associate with successful people. To be successful, you must approach each setback as a challenge, an opportunity for growth. ¶ In early 1987, just a few weeks after his near-death experience, Lakey was given an opportunity to put his new philosophy into practice when he received a call from the IRS, informing him that he hadn't filed his taxes in four years and owed over $40,000. Soon afterwards he received a similar phone call from the state tax board. Between the two, he owed over $50,000. Although he'd been earning a lot of money, Lakey had no savings. In the past, a crisis like this would have driven him straight to the free-base pipe, but with the courage of his convictions, he approached his tax problems as a challenge to be conquered—and conquer he did, paying back everything he owed, plus interest, in three years. It was a remarkable accomplishment to be sure, but something much more

Angel #392, 36" x 48",
mixed media on canvas over wood, 1992.
Donated by Dudley Moore to the Venice Clinic.

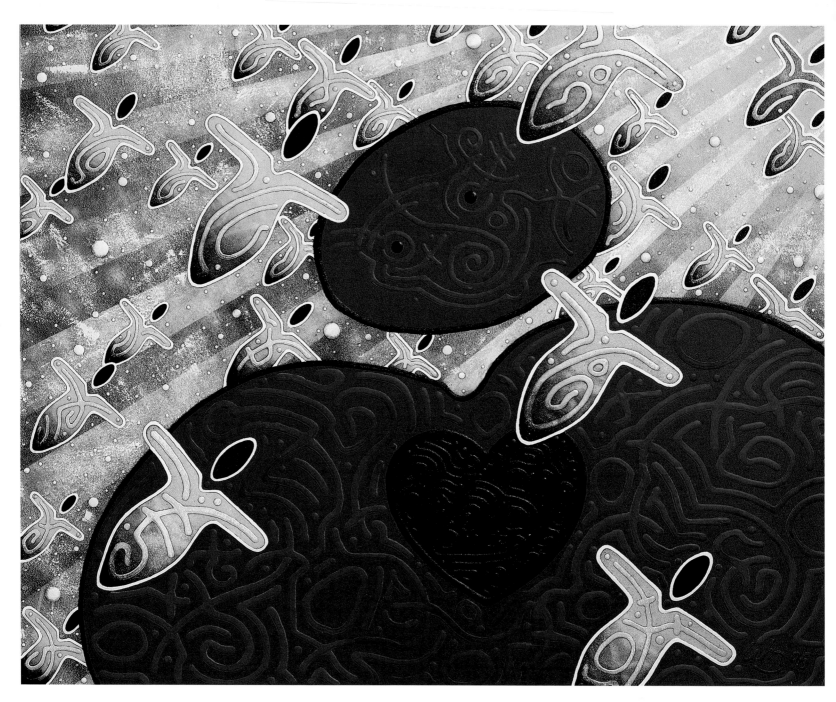

Angel #1400, Purple Man with Angels, *72" x 60", acrylic on wood, 1995.*

remarkable was happening in Andy Lakey's life during those three years, something that transcended the material world of taxes and car sales. ¶ While he put his life together on the outside, Lakey struggled to understand what he had seen and experienced in the other dimension: the love of the seven angels who had saved him, the poles and planets of light with millions of souls floating in harmony. Up to that time he had never read about other near-death experiences, and even today, having done some reading on the experiences of others, he finds little that is familiar. "I didn't see my body lying on the floor of the shower. I didn't walk though a tunnel of light. I didn't meet God or come back with psychic powers." ¶ Like most artists, Andy Lakey interprets experience through the prism of his own artistic vision. And indeed it seems that the artistic vision—the point of view—is the key to his near-death experience. Although he didn't walk through a tunnel of light, he saw tens of thousands of tunnels, what he calls the telephone poles of light, with souls floating through them in single file, so many souls that he believes they must have represented sentient beings from throughout the universe. If this is true, then Andy Lakey had a unique opportunity to watch the workings of the cosmos. How could he express that experience to others? How could he use that vision to keep his second promise to God, the promise to help humankind? ¶ As he began his new life, in a new year, Lakey didn't know the answer to either question. These would come in time. But he felt compelled to understand his experience, to capture the world of angels and light. So he turned to the only expressive talent that had ever come naturally. Always a doodler, he took pen to paper as he had done countless times before; yet he quickly discovered that even that had changed. For the first time in his life, Andy Lakey began to draw. ¶

Angel #960, 38″ round, mixed media on wood, 1994.

KINDRED SPIRITS

by Betty J. Eadie

Betty Eadie revealed the astonishing details of her own near-death experience in Embraced by the Light. *While Andy Lakey's experience was primarily visual and emotional, Ms. Eadie describes specific encounters with spiritual beings and specific messages and insights into the workings of the universe.*

My first introduction to Andy Lakey was when I saw him on national television. From that moment, I was impressed with not only the beautiful message he shared but also his very demeanor. He exhibited a gentle yet solid confidence that I recognized immediately. Perhaps that's why our first telephone conversation was so satisfying to both of us. When you meet and visit with someone who has had a similar experience there is an instant camaraderie; you share something very beautiful and meaningful. When I first spoke with Andy, I felt that I already knew him, that we already knew each other. I also understood that we were each fulfilling our separate missions here on earth.

The idea of a mission is very important to me. During my experience, when Christ told me that it was not yet my time, I realized for the first time that I had a purpose, that each of us has a specific purpose for being on this earth. Part of my mission may be to share with the world the indescribable feelings of love I experienced in that heavenly place. I spread this message of "love one another" through my book and other writings, as well as through speaking engagements and personal conversations with people all over the world. I'm pleased that Andy is spreading the same message through a different medium, the medium of art. Not all of us are here to do the same thing; nor are we all here to reach the same people. Andy's art is going to reach people that my book and other books about angels cannot reach.

Even deeper than our personal connection was the sense of spiritual recognition that I experienced when I first saw Andy's art. I understood immediately . . . the angels, the movement. I understood what they were giving him. There is energy in tone, there is energy in color, and there is energy in design. Andy's angels have a soft flow about them, and yet by design, they are full of incredible energy. He's trying to capture what I saw, what I call intelligences, and they were light energies. The fact that Andy calls them angels is acceptable because they are also protective. As facilitators, they watch over us, but the intelligences are even more than angels.

During my experience, I saw many different spiritual beings. They didn't look like the angels that Andy saw, but angelic appearances depend on the beliefs of the beholder. They can appear to you as you would accept them. If they need to have wings to be recognized, then they will appear that way, though eventually you could see them in their perfection.

I believe that Andy Lakey's art and my own writing and speaking abilities are talents lovingly granted to help us spread the message of divine love. I also feel that, since these talents or skills are God-given, they possess a certain type of energy that propels the recipient forward. It's limitless, because the more you use the gifts you are given, the more they give you in return. I'm excited for Andy and for all the others who are using their gifts and sharing them. In my experience, I was taught that our weaknesses can become our strengths when we use them in a positive way. As I understand, Andy had no previous artistic training; however, God blessed him and gave him this medium of expression.

The experiences that Andy and I have had are life changing. Whether such experiences are positive or negative, they are so profound that there is no returning to your former self. Since Andy's experience turned out to be very positive, his life could not help but be changed. The knowledge that was revealed to him is expressed in his art, and that art is coming from his very core—a core that has changed. Andy's a blessed man. If we never meet on this earth, it's okay, because we already know each other.

Angel #1328, *28" x 30", acrylic on wood, 1995. Collection of Betty J. Eadie.*

SEVEN ANGELS

THE BEST PAINTING THEY HAD

During the early morning hours of January 17, 1994, a massive earthquake rocked the San Fernando Valley north of Los Angeles. Thousands of families lost their homes, sixty people died, and countless more were injured. A three-story apartment building collapsed, burying it's first-floor occupants in the rubble. Highway bridges cracked, closing three major freeways. Gas lines burst, shooting flames into the predawn sky. It was like a war zone, and the battle continued long after the first jolt, with more than five thousand aftershocks in the first two months alone.

In West Hills, just a few miles from the Northridge epicenter, the Tash family lived through a terror that would change their lives forever. That night, nine-year-old Jonathan had a nightmare and crawled in to sleep with his parents, Larry and Cindy. Cindy had to get up early for her job as a dental hygienist, so she decided to go sleep in Jonathan's room. When the quake hit, she was pinned under Jonathan's television set and a chest of drawers, suffering extensive back injuries. One of the family dogs was pinned in with her, and Jonathan never forgot the image of pain and destruction.

"I was so scared during the earthquake," he says today, "because I was really worried about my family and my animals and everything. I couldn't go back to my room. I was just so scared." For almost nine months after the quake, Jonathan insisted on sleeping with his parents. Larry and Cindy tried everything they could to help him face his fears, from stress counseling at school and expensive private therapy to drawing pictures of what he had seen. Nothing seemed to help.

As Jonathan struggled with his fears, his older brother Matthew—who was eleven at the time of the quake—developed a different sort of problem, a deeper, more hidden manifestation of the terror he had experienced. Always a bright, upbeat young man, he couldn't sleep at night and complained of intense headaches. Even more frightening, his parents began to notice one eye was drifting in different directions. They were referred to Dr. Sherwin Isenberg at the Doris Stein Eye Research Center, a division of the Jules Stein Eye Institute at UCLA. After an extensive examination, Dr. Isenberg concluded that the muscles and nerves in Matthew's eyes had become severely weakened. It was a strange condition for a young boy, and Dr. Isenberg believed that the psychological stress of the earthquake had either caused or accelerated the physical degeneration.

Eye surgery was scheduled for May 19, 1994. The night before the surgery, the Tash family happened to see the NBC documentary *Angels, the Mysterious Messengers*. "We didn't really focus on it," Cindy remembers, "but the entire special was very interesting and we saw the angel paintings by Andy Lakey."

The following morning, Matthew went through a presurgical examination at the research center. At that time, Lakey's large, beautiful *Angel #4*—which had been donated by actor Ed Asner three years earlier—happened to be on display near the pediatric exam suites, directly opposite the elevator. The painting was on a rotating schedule among several locations so as many children as possible could experience it, and Matthew had actually passed by it several times before, during previous visits to the center, without taking notice. That morning, frightened by the upcoming surgery and with the images of the angel documentary still in his mind, he saw Andy's angel with new eyes:

"I walked out of the elevator and noticed the big painting of Andy's. I went over to it and touched it. I knew there was a presence around me 'cause I felt a chill and I could feel tingling in my body. I was scared about the surgery, and I heard a voice saying it would all be okay. . . . I knew it wasn't somebody or my mom saying it would all be okay. It was an unfamiliar voice, but it didn't scare me, and it didn't speak out loud. I couldn't hear it with my ears. I had to hear it with my mind."

After hearing the comforting voice, Matthew faced his surgery with confidence. "I was nervous and anxious," he admits, "but I wasn't scared like I was before. I knew it would be okay."

While recovering, Matthew happened to see another television feature on Lakey's work, and he asked his mother if they could try to contact the artist and maybe buy a painting. "He had never expressed any interest in art," she points out, "but it was obvious the painting had touched him on a personal level." As they continued to talk, Matthew revealed his experience with *Angel #4*. Cindy agreed to try and contact Lakey, but in the meantime, Matthew required a second surgery, scheduled for September 9.

In a bizarre twist of fate, *Angels, the Mysterious Messengers* aired again the night before Matthew's second surgery. This time, he paid close attention to the show, especially the feature on Andy Lakey. The next morning, he again went to the Doris Stein Center for a presurgical exam, and once again when the elevator door opened, he saw *Angel #4*. "I walked over and felt the painting," he remembers, "and the same thing happened. I felt a chill and a tingle and heard the same voice."

The second surgery was more successful, and two weeks later Matthew bought a Lakey angel painting out of his own savings. By that time, he was twelve years old, Andy's youngest collector, but an even younger collector followed. When Matthew brought the painting home, his brother wanted one, too, so the following week, Jonathan Tash also purchased a Lakey original out of his savings. His parents hung the painting over the bed in his room—the room he had refused to enter ever since the earthquake.

"When I saw the painting, I realized it gave off a power, and I didn't have to be scared anymore. It was like a being . . . it said stuff like, 'Go back to your bed. It's okay, you have nothing to worry about.' It felt so good to know I was being watched over. I knew there were angels, but I didn't know they would watch over you. It was like they told me, 'We're always watching over you and your family. We'll always be together.'"

Jonathan Tash slept in his room that night for the first time since the earthquake, and he has continued to sleep without fear every night since, knowing that Andy's angels are watching over him. Like his brother, Jonathan makes it clear that the voices he heard never spoke out loud. They spoke a deeper language, the language of the heart and mind and spirit.

After the second surgery, Matthew's condition improved, but he still complained of headaches. Although the ophthalmologist had ruled out a brain tumor in the initial examination, he now decided that it would be worthwhile to do an MRI, just to make sure. Matthew wanted to hold his personal angel painting during the procedure, but the medical staff refused. Instead, Cindy Tash stood outside the imaging room, holding a miniature Lakey painting she had recently acquired up toward the

huge MRI machine. By that time, Cindy had established a personal relationship with Andy Lakey, and when she told him of the MRI, he suggested that she "look at the painting and try to have that energy focus in Matthew's direction." The radiologist at the MRI facility detected disturbing shadows in the sinus area and sent the images to the radiologists at the Jules Stein Eye Institute for further analysis. When they read the images, the shadows were gone. There was no evidence of abnormality.

Today, Matthew Tash smiles and says, "I feel great. My eyes are perfect." Jonathan sleeps soundly in his room without fear. And though Cindy still has back pain, she too sleeps without fear. Larry Tash is quieter about his feelings, a bit more skeptical perhaps, but he sees the healing that has occurred around him. "I don't know that I believe in angels," he offers, "but I know that the experience Cindy and the boys felt was important and helped them through a very difficult situation."

"It totally changed the atmosphere in this house," Cindy explains. "We never even discussed angels before. We weren't particularly religious. But Andy's paintings have helped us to open up to what's really out there."

Matthew puts it more simply, comparing Lakey's *Angel #4* to prints of other paintings that hung beside it in the eye research center. "They had Van Gogh paintings and Monet paintings there, but to me Andy's angel was the best painting they had."

Drawing is thoughtful and deliberate. Doodling is aimless. We value drawings and hang them in our museums, but we don't value doodles in the same way. "It's just doodling," we say. Yet, from early childhood—long before his life-changing, near-death experience—doodling had been a strange, compulsive passion for Andy Lakey, a crucible for the visionary artist to come. "I don't think I ever drew a picture," he says today, "even as a child. But I always loved to doodle. It was a way of dealing with frustration. A way of expressing myself." Most of the time it was unclear exactly what was being expressed. Lakey's doodles were always abstract, with intricate, mazelike lines, a pre-cursor to the intriguing lines that add depth and movement to his angel paintings. His doodles got him into trouble repeatedly in school, when teachers found his tests and homework assignments covered with strange shapes and tight little boxes. Even in his high school art class—which he took because it was easy, not because he was interested in art—he sat in the corner and doodled. "My art teacher would say, 'Why don't you draw for real?' But I just wasn't interested in that. I don't think I ever actually finished an art project." Lakey doodled his way through the Navy, too. Paper was in short supply at sea, so he often worked on the same piece of paper, over and over again, until every space was filled with tiny, intricate lines. "I doodled on one sheet of notebook paper for six months," he recalls with a laugh. "I wanted to see how much I could get in there." Despite his meticulous, almost obsessive attention to his doodles, Lakey never considered them actual works of art. They were just a way to pass the time. When the paper was full, he tossed it out the porthole. By the time Lakey was in his teens he associated his doodling with drug taking, calling them his "high doodles." This continued after the Navy, when he went through a difficult time of adjustment to civilian life. "I was pretty depressed," he admits, "even suicidal at times. I put up this big bristle-board in my room. It was about four feet by three feet. And every time I got high, I'd draw a line on the board—just one

C H A P T E R T W O

Ball of Light

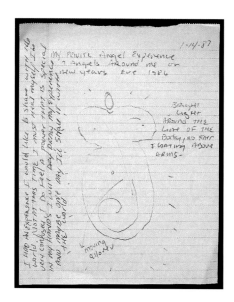

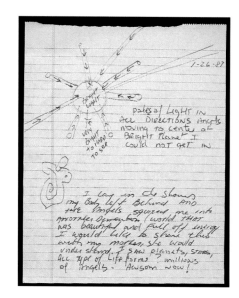

Early angel sketches, ink on paper, January 1987.

line with one of those pens that creates a gold or silver outline around the main line. I thought that somehow, if I studied all these lines, I would understand the way my brain worked when I was high. My roommate at the time used to say, 'God, Andy, if you could only draw real things, you could be an artist.'" ¶ With a strange compulsion, Lakey would work on a single doodle for a year—as he did with the big bristle-board—filling every space with lines over lines upon lines. These complex, "busy" doodles illustrate the movement of the artist's hand rather than the conscious creation of shapes. Some Lakey doodles, in which he created a mazelike structure, echo the doodle-like drawings of Keith Haring, a contemporary of Lakey with whom his mature work has often been compared. Yet Andy Lakey never heard of Keith Haring until others made the comparisons. ¶ It seems clear that in his early scribblings and his fascination with the workings of his own mind, Andy Lakey had already discovered a direct creative connection between his subconscious and his hands, a connection that plays such an important role in his work today. But up to this point he really had nothing to express, no "real things" in the words of his roommate, just lines, lines, and more lines. He couldn't seem to move beyond them, couldn't turn his lines into art. He didn't

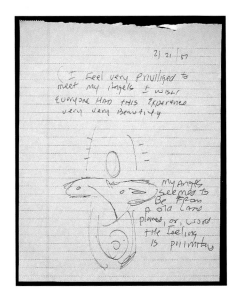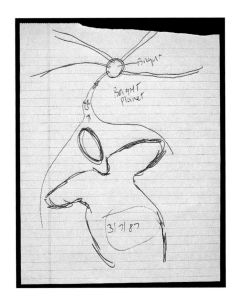

Early angel sketches, ink on paper, February and March, 1987.

want to draw anything representational—people or landscapes—and even today, after years of full-time professional development, he has difficulty depicting a likeness or an object. Yet, he was obviously reaching for something in his compulsive doodling, an artist in search of a subject. Lakey's near-death experience on New Year's Eve 1986 gave him that subject. For the first time, he had something he really wanted to draw, something he wanted to represent—initially for himself, later for others to share and understand. He wanted to draw the angels who saved him and portray the cosmic dimension of light. ¶ Lakey's first drawing is dated January 14, 1987, exactly two weeks after his experience. It features a faint, rough, amateurish version of the angel figure that now graces his paintings, with a few cryptic, swirling lines within its body and other lines around the figure to represent light emanating from the angel. The notes that Lakey wrote with the image are as illuminating as the drawing itself. On the top of the page, he scribbled, "My Private Angel Experience / 7 Angels Around Me On New Year's Eve 1986." Beside the angel image, he indicated, "Bright Light Around the Line of the Body, No Face Floating Above Arms." Finally, along the side of the page, he wrote, "I had an experience I would like to share with the world. Not at this time. I

must heal myself. I'm very confused. I do feel a power that is special in my hands. I will draw my experience and maybe one day I will share it with the world." ¶ This sketch was the beginning of a remarkable process of spiritual healing and artistic development. "Drawing became my therapy," Lakey explains. "Instead of coming home and taking drugs, I came home every night to draw. I really wanted to capture the essence of the angels that I saw in the shower, my angels." During the next three years, he created thousands of sketches, all variations on the same theme, all attempts to capture and understand his experience. Most of these sketches ended up in the wastebasket, as he tried again and again to get it right, but he saved the sketches that came closest to what he was trying to express. On these he wrote his thoughts concerning the experience, the sketch, or both—in simple, often ungrammatical, yet heartfelt language—creating a unique illustrated journal of his rebirth as a human being and his birth as an artist. Today, Andy Lakey has 227 of these sketches, all done in ballpoint pen on lined yellow notebook paper. "Those sketches mean more to me than all my paintings," he says. "They're my private record of how I became the man I am today." ¶ On January 26, 1987, he drew a circular form to represent one of the planets, labeled "Bright Light," with eight poles of light piercing the planet and arrows within the poles to represent the flow of souls. On the outside of one pole is an angel figure that represents Lakey himself approaching the pole. "Poles of light in all directions," he wrote. "Angels moving to center of bright planet. I could not get in." At the bottom of the page: "I lay in the shower. My body left behind and the angels squeezed me into another dimension/world that was beautiful and full of energy. . . . I saw planets, stars, all type of life forms? Millions of angels." ¶ In time, the drawings became less of a personal journal and more of an artistic exercise, as Lakey began to focus on the angel figure that has become the icon of his work. On February 18, only six weeks after the experience and a month after his first drawing, he was already perfecting the shape of the angel's body, with the oval head floating above it. "Arms straight out," he wrote. "All parts of body and head very smooth and rounded." Three weeks later, on March 7, over a similar drawing he wrote, "This is a close-up of my angel. It's not perfect, like I see it in my mind. I'll keep working on drawing this. I feel so close to them, it will come out. . . . I can't explain, but I know they are with me." ¶ Over the next three years, Lakey's sketches became stronger and more controlled, with a sense of movement in the angel forms. It's a measure of the artist's excitement at his own development—as well as his naiveté about the art world—that he

My Hands, 14" x 10",
ball point pen, 1990.
Collection of the artist.

BALL OF LIGHT

39

submitted some of these later sketches, still on lined yellow notebook paper, to several galleries. The results were predictable: polite but firm rejections. Lakey was undaunted, and he could feel that something was changing inside, something guided by the angels themselves. On July 25, 1989, over a simple drawing of an angel's featureless oval head, he wrote, "I'm not sure why . . . I feel a shift in the angels. Something is happening?" ¶ Something *was* happening, not only within Andy Lakey but in the material world around him. Following the precepts of his self-help books, he made new, successful, positive-thinking friends. He joined a gym, went to church, socialized in young, professional singles groups, and began to live his life differently. He continued working in sales, bouncing back and forth between selling cars and computers, while making monthly payments to the IRS, usually just enough to cover the interest on his huge tax debt. He managed to buy a small condo in the exclusive community of La Jolla, north of San Diego, closing the deal without interference from the IRS, though they slapped a lien on the property two days later. Such leniency was unheard of at that time, and Lakey still believes he had an angel—earthly or otherwise—working for him in the Internal Revenue Service, because the condo he should never have been allowed to buy turned out to be the key to yet another new life. ¶ On October 15, 1989, under a strong sketch of an angel floating upward across the page, Andy Lakey wrote, "My birthday in one week . . . the Big 30." In all his sketches, it's the only comment that doesn't directly relate to his art or his near-death experience. Birthdays take on as much meaning as we give them, and Lakey obviously saw great meaning in this one. It was a time to take stock, a time to consider what he had done with the new life he had been given by the angels. On the one hand, he had much to be grateful for. He was healthy and drug-free. He had plenty of friends and a fair share of relaxed, romantic relationships. He had a talent for making money, and he was in the process of getting a second mortgage on his condo, which would allow him to pay off the IRS in one lump sum. In less than three years, he had completely turned his life around. But something was missing; something still gnawed at him deep inside. He knew he needed to change. ¶ "I had a mid-life crisis," he says today. "Or an early mid-life crisis. I knew I didn't want to spend my life selling cars. I felt very frustrated, and my great joy was coming home after work and creating my angel drawings. I got such pleasure from it. It healed me. It made me feel whole. Then all of a sudden it came to me—what if I could sell my angel drawings?" ¶ Never one to think small, Lakey quickly progressed beyond the idea of selling his drawings. On

Intermezzo, *32" x 40", acrylic on canvas over wood, 1990. Collection of the artist.*

Hell, Earth, Grass, *40" x 32", acrylic on canvas over wood, 1990.*

his thirtieth birthday, October 22, 1989, he made a bizarre, yet bold decision. He decided to quit his job and become a painter full-time. ¶ "I went into work and told my boss that I was giving him two weeks notice, because I'd decided to become a painter. He looked at me like I was crazy. He thought I was doing drugs again. He suggested that I see a psychologist. I convinced him that I was serious, that I'd made up my mind, and he was very nice about it. He told me I didn't have to give him two weeks notice, that I could start right away, and that there'd always be a place for me if I wanted to come back." ¶ Anyone with even a casual knowledge of artistic careers would understand the incredulous response of Lakey's boss. After all, here was a thirty-year-old man, making a good salary as a salesman, suddenly deciding to throw it all away to paint. On top of the simple economics, Lakey had no artistic education or formal training. He hadn't studied the work of other painters, and he knew nothing about the life or techniques of artists who had come before him. He had never been to a museum or a gallery. He had never created a single painting. During his three years of drawing, he occasionally bought a tube of paint and experimented with adding colors to his drawings, but it had never worked. He just didn't understand how to use paints and

Moon *and* Sun *(left to right), 24" round, acrylic on wood, 1990.*

Ocean, *32" x 40" acrylic on canvas over wood, 1990.*

brushes. ¶ Today, with the hindsight of his later experiences, Lakey believes his artistic development was guided by the angels. He sees his three years of drawing as a period of artistic training, during which he proved to his guides that he had the discipline to work at his art day after day. And he sees the decision to become a painter as the next logical step in that development, a step that ultimately allowed him to touch others and give something back to the world. At the time, however, he was not aware of the angelic guidance. The desire to paint was simply an overwhelming urge from within. He had to paint because he couldn't do anything else. ¶ Despite his total lack of art education and experience, Lakey embarked on his newly chosen career with the courage that comes with naiveté. "I figured it would be easy to paint," he admits. His friends were skeptical and regarded him with incredulity. "I guess they weren't positive enough for me, but there was one person who was positive. Domonic Mongello. He said, 'Hey, you want to be an artist, go for it!' Domonic was as wild and crazy as I was." ¶ Mongello and Lakey had met in the Navy, two wild-eyed adventurers on a ship full of half-stoned sailors. Mongello liked to write poetry, and he was fascinated with Lakey's incessant doodling. Back then, they were partners in insanity, doing all kinds of destructive

"Andy's work inspires the soul and warms the heart.... I feel like I am transported to a warm, safe place whenever I gaze at his art."

PAULA COXE
AUTHOR OF *FINDING PEACE*
WEST LINN, OREGON
MAY 1995

54th Regiment, *40" x 32", acrylic on canvas over wood, 1990.*

and dangerous things. Now they became partners of a different kind; some might still call it insanity, but if so, it was the constructive insanity of the artist. ¶ With Mongello's help, Lakey began to create an art studio. Neither of them actually knew what an art studio looked like—they'd never seen one—so they went to a fine-arts bookstore and bought art books and magazines that contained pictures of studios. They got a general idea and began to convert one of the two small, detached garages that came with Lakey's condo. The two friends threw up drywall and splattered paint to give it an arty look. Mongello wrote poetry over the paint, while Lakey went to an art supply store to buy the tools of his new trade. ¶ "They saw me coming," he recalls with a laugh. "I was a salesman myself, so I should have known better. I proceeded to buy about five thousand dollars worth of art supplies. That was almost my entire savings, all I had to support myself, and I spent it in one day. I bought everything: every paintbrush you could imagine, every type of paint, air brushes, canvases. You name it, I bought it. Then I sat down and tried to paint what I drew—the way I drew—but it just wouldn't come out. It was terrible. It looked like mud, just layers of mud splattered on the canvas. I call them my mud paintings." ¶ One friend actually bought one of Lakey's "mud paintings" because she felt sorry for him. She later asked for her money back and, despite his endless optimism, the artist realized that sympathy buyers weren't going to support his career. Painting wasn't as easy as he thought it would be. He needed a greater understanding of the medium. He needed technique. Guidance. Insight. Something. On January 3, 1990—three years and three days after his near-death experience—Andy Lakey got what he needed: "One morning, I woke up and felt very excited, very happy—and I knew deep down in my heart it was my angels . . . it was God telling me that He had something special for me to do and something special was going to happen to me that day. I went down into the studio—which was rigged so that when I turned the lights on, the

Earth, *30" x 42", acrylic on canvas, 1990.*

radio came on, too—and when I flipped the switch, the lights came on and the radio was playing the Rolling Stones' song 'Satisfaction.' ¶ I sat down next to one of the 'mud paintings,' and I bowed my head, almost meditating. Even to this day I don't really meditate; I pray in my own way. But that morning I was almost in a meditative state. I raised my head up and a little ball of light floated through the other side of the wall and hit me right in the forehead. The light wasn't especially bright or intense—more of an ethereal glow, similar to the glow within the telephone poles of light in my near-death experience. Only now I wasn't dying or high on drugs. I was clearheaded and wide-awake. ¶ The ball of light enveloped my body, filling me with pure love, pure energy. Today, every time I create a painting, people say they feel something, that something is happening with the painting. That feeling is real. It's the same pure love, pure energy that I felt from the ball of light. The light surrounds each one of my paintings in its own way. ¶ I found myself communicating with three men. They were definitely my angels. I don't remember what they looked like, but they had features—not like the featureless figures in my first experience. They had beards, whitish hair, very light in color, very bright. I was communicating with them, but they weren't talking to me in words. They were giving me information telepathically, and I knew exactly what to do. I was to paint 2,000 angel paintings by the year 2000. ¶ They would take care of everything. I knew they would give me my art technique, they would teach me to paint. They weren't going to sit down with me and instruct me and tell me the primary colors. They would just give me the knowledge to paint and make circumstances available for my success. The last thing they communicated was that I would meet them again in the year 2000." ¶ Lakey later explained that the experience seemed to last for a long, yet indefinable time. "I can't say it was an eternity or ten hours or three hours." Yet, when the angels had disappeared and he was sitting alone in his studio, in front of the "mud painting" that didn't work, "Satisfaction" was still playing on the radio. In earthly time, Andy Lakey had received a cosmic mission, with angelic assurance of artistic support, in a matter of seconds. ¶

Angel #198, *48″ x 36″, acrylic on wood, 1991. Collection of Jerry and Sho Simon.*

Overleaf : Angels Retrieving Creature, 55″ x 30″,
acrylic on canvas over wood, 1990.
Collection of Marc Stein.

THE SOURCE OF GENIUS

by Raymond A. Moody Jr., M.D.

A world-renowned scholar and researcher, Dr. Raymond Moody is the author of seven books, including the groundbreaking examination of the near-death experience, Life after Life, *which has been translated into seventeen languages since it was published in 1975. With doctoral degrees in both philosophy and medicine, as well as extensive experience as a practicing psychiatrist, Dr. Moody brings a unique perspective to his research and analysis of near-death and other paranormal experiences. The following thoughts on what Raymond Moody calls the "Paranormal Andy Phenomenon" are adapted from Moody's forthcoming book,* Humor and the Hereafter: A New Philosophy of the Paranormal.

The near-death experience that Andy Lakey recounts exemplifies how wondrous artistic talent can come on the heels of profound spiritual encounters. Sorry to have to tell you this, Andy, but a few of your fellow great artists of the past received their creative gifts supernaturally without having to almost die in the process.

The ancient Greek poet Hesiod's works are among the oldest surviving written relics of the Western literary tradition. Hesiod took up the music business because the Muses, the feminine spirits who the Greeks believed bestowed creative inspiration on mortals, instructed him to do so. Hesiod caught sight of the Muses dancing around a spring one day as he grazed his sheep on Mount Helicon. "We know how to make up fancy lies, it is true, but we also can tell the truth, when we've a mind to," the Muses sang to the shepherd. After his vision, Hesiod devoted his life to making poetry and song.

In a work that some regard as the earliest history of England, the Venerable Bede (c. 673–735 A.D.) recorded the story of Caedmon, a man who was transformed overnight into a great poet and songwriter by a powerful supernatural visitation. Caedmon was a shy person and at dinners—where by custom each guest was to sing for the whole party—when Caedmon's turn came, he always would find some excuse to hurry away, embarrassed. One evening, after just such an episode, he settled down to sleep in the cattle byre, because it was his night to stay on guard. As he slept, he had a vision; someone standing beside him in the darkness said, "Sing to me, Caedmon." When Caedmon replied that he could not sing and that he had left the feast early for that reason, the figure persisted: "Sing to me anyway. Sing about the beginnings of the world." Suddenly, Caedmon burst forth in melodious songs, verses that he had never before heard, and when he awoke the next morning, he still had his new and miraculous talent. Caedmon spent the rest of his days making music with his preternatural gift, and his verses enjoyed a holy reputation far and wide.

Andy Lakey's amazing artistic gift descended upon him after a near-death experience that dramatically changed his life for the better, and the lives of many other persons around the world as well. Andy obviously has to resort to non-literal language in order to put his astonishing vision into words for us. One of the most common things that persons who have had near-death experiences can be heard to say is that there are no words that can describe what they went through when they were transported to a realm of love and light. I hear often of this whirling and tunneling, in Andy's case a tunneling of angels, that he felt and perceived around him as he lay on the verge of death. And when Andy describes being lifted up among planets, what he

says compares very nicely with what one of the greatest modern pioneers of the study of the mind—Carl Jung—said about his own near-death experience. During a cardiac arrest, Jung felt himself catapulted far up into the heavens, into a planetary dimension of ineffable geometrical configuration.

The notion of genius, or creative spirit, underwent a long and tormented transmutation from the paranormal through the abnormal into the supernormal. In the nineteenth century, it became fashionable among the Romantics to attribute their own renowned creative talents to mental disorder, and the famous "mad genius

controversy" ensued. Interestingly, Charles Lamb, who was the only one of the Romantics who had actually been hospitalized for a mental illness, strongly denied that his experience of psychosis was in any way related to his creative faculty. Nonetheless, the mad genius controversy had the effect of drawing the concept of genius squarely into the domain of psychology. But when the madness-genius equation in its simple form did not pan out, psychologists reconceptualized genius as greatly elevated I.Q.

This is a telling example of how prematurely opting out of the paranormal's slant on universal human experiences can have unfortunate consequences. It is a fairly common experience among artists and writers to have an uncanny feeling that their works emanate from sources outside of themselves. According to Richard Bach, *Jonathan Livingston Seagull* was dictated to him by a disembodied voice. Writers may have the strange feeling of being "led" to an essential reference at a critical juncture of a project; composers may "hear" music in a dream.

So the Greeks' idea of Muses may seem a better intuitive fit to some of the anomalies of the inner lives of persons engaged in creative work. The modern reformulation of the concept attempts to move the locus of control of the creative process to within the writer or artist, but in the good old days a work of genius was one over which the artist or writer was thought to have little or no control, just as Andy Lakey explains that he is being "guided" in the creation of his paintings. By contrast, the contemporary definition of genius in terms of high I.Q. seems to have no heart. The outcome of this has been that an entire, historically important category of eerily baffling but fairly common experiences familiar to many creative people remains unappreciated by mainline psychology.

In the old Greek sense, Andy is indeed in the grip of genius. Through what has been happening to him after almost dying, Andy in effect has transmorphed into a living, breathing, painting, paranormal phenomenon in and of himself. Another mind-boggling aspect of Andy as a living paranormal phenomenon is that his personal paranormality is purported sometimes to be transmitted to other people through the medium of his art. It appears that Andy has come down with a case of the Daedalus Syndrome, if I may call it that. Daedalus of Greek mythology fashioned works of art—statues—that took on lives of their own and seemed to move by paranormal powers. So too, it seems, with the paintings of Andy Lakey.

WATCHING OVER ME

by Andy Lakey

As Andy Lakey began a new life by sketching the angels who had saved him, he thought back over his old life—not only of the wrong turns he had taken in adolescence and adulthood, but of his childhood, the beginnings of his earthly journey. The more he considered his early life, the more convinced he became that the angels had been there for him all along, watching over him and protecting him.

It was in Merced, California—where my father was stationed at Castle Air Force Base—that I first had a sign that my angels were watching over me. At least that's the way it seems when I look back on it today. I was only two years old when this happened, so I don't remember it myself, but the story's been passed down in my family and was even published in a popular magazine.

My father and I were playing near a tree in the front yard. My mother was taking a shower inside the house, and she says she had a "feeling" that I should come inside, so she stepped out of the shower, soaking wet, and called for me. My father doesn't remember hearing her call, but he remembers me bolting away, and him running right after me. A split-second later, a carful of drunken teenagers hurtled over the curb, ripped across our lawn, and smashed into the tree—right where my father and I had been playing. My mother watched it all, screaming in terror, and she swears to this day that the car seemed to pass right through me without touching me. You can call it mother's intuition or angelic intervention, but I know that a higher power protected me.

I had another close call around the same time, maybe not as miraculous, but just as dramatic and dangerous. My mother was playing with me on the edge of a big swimming pool on the base, and I slipped between her legs, falling into the deep water.

She couldn't swim, so she panicked and screamed for help. My father—who had been trained as a lifeguard—came running from the other end of the pool, dove into the water, and pulled me out, wet and scared but very much alive. It's interesting how things work out. My father and mother broke up shortly afterwards, and he was never much of a father to me at all, but he saved my life in the pool, and I saved his when I ran away from the tree. Or maybe the angels saved us both.

When I was eight, my family moved to Japan during a period of intense anti-American feeling, with demonstrations outside the bases and an overpowering fear and tension in the air. My stepfather was stationed at Yokota Air Force Base, near Fuji, and one day we drove to an air show at another base outside Tokyo, about eighty miles away. In the middle of the show, I turned around and my parents were gone. I went to find their car, but it wasn't where they had left it. (I later discovered that my stepfather had moved it.) So I decided to walk home—a totally crazy idea, but that's the kind of kid I was. I strolled right past the front gates of the base, and the guard waved me through: eight years old, and he just let me walk out from the protection of the American base into a strange, and, at that time, hostile country. We lived near the railroad tracks at Yokota, so I found some tracks and started walking. I didn't understand that I was eighty miles from home.

I walked for several hours until it began to get dark. Frightened, lost, and desperate, I just sat down on the railroad tracks and cried. Suddenly, I felt a hand on my right shoulder. I looked up to find an old Japanese man, dressed in the simple clothing of a farmer, gazing down at me with kind, dark, and ancient

eyes. I had a grand total of ten yen in my pocket—which was worth about three cents—and I held it up to him and said one word, "Yokota." He pointed to the other end of the railroad tracks; I'd been walking the wrong way! Then he motioned for me to get into his "putt-putt," a small three-wheeled truck that was very popular in Japan.

The old man drove me all the way to Yokota, a ride that seemed like hours in the little putt-putt. Once we found the neighborhood, I was able to direct him to our house, and we pulled up just behind my mother and stepfather. I could see my mother crying hysterically on my stepfather's shoulder—I'd been gone for eight or nine hours. When she saw me get out of the putt-putt, she stared as if she was in a state of shock. She just couldn't believe it was really me. It turned out that both bases had been on full-alert; they'd been searching for me with helicopters, and the story had been broadcast on television. A lost child is always a frightening situation, but in those days, with the anti-American hostility, a lost American child in Japan was like a national emergency.

Who was this old Japanese man? Was he an angel? I don't know. But I do know that he came out of nowhere to help me, just when I needed it most. After dropping me off, he just drove off and disappeared. I don't think he even took the ten yen.

After three years in Japan, my stepfather was transferred to a base in Wichita, Kansas. While he and my mother went to look for a house, my sister and I stayed with his parents, who lived a couple of hours away. At this time I still thought that my stepfather was my real father, so I thought they were my real grand-parents. They were wonderful people, and I remember the week I spent with them as one of the happiest times of my life. They took us to all kinds of fun places, did all the things grandparents do with their grandchildren.

When the week was over, Grandma and Grandpa Lakey and their younger son, my "uncle," drove us down to meet my mother and stepfather. Grandma Lakey was a very religious lady, and I still remember riding in the back of the van, listening to her read to us from the Bible. After dropping us off, they got right back in the van and headed home; they didn't even stop for a cup of coffee. Less than two miles away, the Lakeys got into a horrible car wreck. Grandpa Lakey and my uncle were killed instantly, and Grandma Lakey was permanently paralyzed. I was devastated; we all were. I went with my stepfather to look at the smashed-up van in the junkyard, and I remember thinking how strange it was that we had spent the whole week going places in that van, and that my sister and I had been in it less than ten minutes before the accident.

Now a skeptic can look at each of these incidents and say, "The kid was just lucky. His mother happened to call him at the right time. His father happened to be at the pool. He happened to run into a kindly Japanese man. He happened to get dropped off just before the car accident." I suppose that's possible, but after meeting my angels face-to-face and after living through the miraculous events that followed, I don't believe in the simple definition of "luck." Sure I was lucky, but lucky on a deeper level than many of us imagine. I was lucky because my angels were watching over me.

In his bestselling book *The Celestine Prophecy*, James Redfield describes the mysterious and powerful nature of what we call coincidence: "These coincidences are happening more and more frequently and . . . when they do, they strike us as beyond what would be expected by pure chance. They feel destined, as though our lives had been guided by some unexplained force." Redfield emphasizes that, while this idea is not new, the number of people who are aware of these "coincidences" is increasing dramatically as we approach the millennium. Andy Lakey is clearly one of those people, and he learned the lesson from personal experience several years before Redfield's book was published, on the day that three angels came to him in a ball of light. Today, Lakey states simply, "There are no coincidences." He believes that everything that has happened to him since that day has been guided by the angels. Actually, he believes that he's been guided ever since his near-death experience, but that guidance reached a new level of power and clarity after his vision: "Since 1990, I've been on autopilot. The best way I can explain it is that if you plopped me down in the middle of a strange city, I would know exactly where to go. Except I'm not in the middle of a strange city, I'm in the middle of my life. I don't hear voices telling me where to go or what to do. I don't really get any 'messages' in words at all. But I just 'feel' the right direction, like a sixth sense. I'm not always right, of course; occasionally I take the wrong path, act on the wrong insight. But that's only happened a few times in the last six years. Part of it was learning to pay attention. The angels communicated to me that certain people would enter my life to help me on the path, so I began to look at each person I met—and each experience, too—as someone or something that could teach me something. I would say to myself, 'Is this the person who will help me? What can I learn from this person or this experience?' And ever since I began to do that, ever since I was hit by the ball of light, almost everybody who comes into my life *does* have a purpose. Even when I'm wrong—when a relationship

CHAPTER THREE

Angel Power

turns out to be negative—that becomes a learning experience and moves me forward on the path. Everything just works." ¶ Skeptics may question the reality of Lakey's vision, just as they question the visions of shamans and psychics from cultures all over the world. And, of course, it's impossible to objectively measure the validity of a vision. We can only look at what happens in the outer life of the visionary. By that standard, Andy Lakey's vision must have carried remarkable power and meaning, for as soon as the three angels disappeared, he began a full-speed, guided journey through the world of "coincidences" straight to creative fulfillment and artistic success. ¶ It began with a couch. "Right after the ball of light," Lakey remembers, "I decided to look for a couch. I didn't actually need a couch, and I didn't have the money to buy one, but I felt this powerful urge to go shopping for a couch. I went to a furniture store and was immediately drawn to a big, beautiful painting on display above one of the couches. It was about four feet by six feet, with long, thin, colorful lines that created abstract faces. I remember thinking that if I could only apply lines with paint the way the artist had in that painting, I might be able to paint my angels the way I drew them." ¶ Excited by what he saw in the painting, Lakey discovered that the artist was Roger Hinojosa, who lived in Sedona, Arizona—an interesting connection, since Sedona is considered by many to be one of the "power places" of the earth. The salesperson at the store gave him Hinojosa's phone number, and Lakey raced straight home to call the painter: "I called Roger Hinojosa, and I said, 'Roger, my name is Andy Lakey; I became an artist today.' He didn't laugh, he didn't chuckle. He was really helpful, really open-minded. He didn't give me a whole lot of advice: 'Just work with your paintings,' he said, and then he told me to buy a particular brand of paint from a particular company. Now if I never went to look for a couch, I would never have found Roger's painting, and I would never have found this paint. And without this particular paint my technique would not be possible." ¶ As soon as he hung up with Roger Hinojosa, Lakey called the paint company and ordered some basic colors. He felt as if something was happening, something mysterious and wonderful. But the wonder was only beginning. Later that same day, he found himself guided to a particular restaurant in La Jolla. "It was a fancy place," he recalls, "very elegant, something I wasn't really used to. I was pretty tight with money, but for some reason I wanted to go and eat there. I walked in, and I didn't order anything, but I saw the art of Paul Maxwell. Even to this day, there is something very special, very magical about his work." ¶ Like Roger Hinojosa, Maxwell created abstracts with lines, but whereas

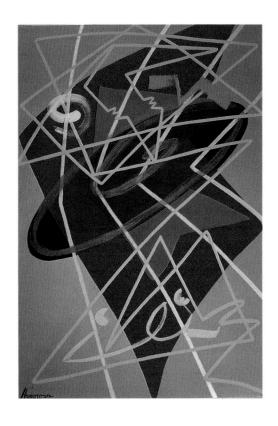

Emergence *by Roger Hinojosa, 48″ x 72″, acrylic on canvas, 1989.*

Hinojosa employed a few long lines that snaked throughout the painting, Maxwell used thousands of tiny, fine lines in his work. What really caught Lakey's attention, however, was the physical foundation on which he applied his paint. Lakey took several pieces off the wall and examined them. He discovered that Paul Maxwell painted on canvas stretched over solid wood, rather than on the more traditional foundation of canvas over stretcher bars. "Something clicked immediately," the artist recalls. "I realized that I had to paint on canvas over wood, so that I could apply the paint more thickly." ¶ Lakey left the restaurant without ordering a meal, just as he had left the furniture store without buying a couch. Clearly, he was on a different sort of mission, looking for ideas and inspiration. The next day he went to a lumber store, bought an 8' by 4' hollow door, and had it cut into two 4' x 4' pieces with their edges sealed. Then he stretched canvas over the wood. By the time the boards were ready, his new paint had arrived. He sat down in his studio and began to paint, full of confidence that he was now on the right track. But it still didn't work. It still looked like mud, only now he could lay the "mud" on thicker than before. Something was

missing—and that something was supplied by yet another instance of divine guidance. ¶ "I knocked over a gallon of this new paint—the paint that Roger Hinojosa had told me to order—and it splattered all over the work table. There was so much paint that the force of it flowing across the table knocked over a paper cup full of a different kind of paint, one of the original paints I had bought at the fine-arts store. Normally, I'm extremely careful about cleaning up my work area, but for some reason, after spilling this whole gallon of paint, I got disgusted and decided to quit for the day without cleaning it up. I figured I'd chip it off after it dried. ¶ The next morning, when I returned to the studio, I found this big mess; the paint was still wet, dripping all over the work table and onto the floor. Both of the puddles—the big one from the gallon container and the small one from the paper cup—were flat and runny, but where the two paints had mixed together, I noticed this hard, lumpy texture, like a raised area in the flat puddles. I touched it, and it was smooth. I said, 'Ooooh!' I remember getting a glass to mix the two paints together. Then I poured the mixture onto the table, and it stayed up, kept its form. I tried pouring a little of the first

Light Poles/Black Universe, 60" x 42", acrylic on canvas over wood, 1990. Collection of Robert Dalter.

paint out by itself, then a little of the second paint by itself, but they both flattened out. It was something in the mixture of those two paints. Then I thought, 'What if I squeezed it out of tubes?'" ¶ Lakey rushed straight to the art store and bought over a hundred plastic tubes as well as a gallon's worth of the original paint he had purchased at the store, an expensive proposition because it only came in tiny containers. When he returned to the studio, he poured a gallon of each paint into a five-gallon metal bucket and stirred it with a broom handle. Then he filled the plastic tubes with the mixture and went to work, squeezing the paint over lines he had drawn on the canvas. From the very first line, he knew he had made a quantum leap; for the first time since his decision to become a painter, he was able to paint the way he drew. ¶ "I was so excited!" Lakey remembers. "After doing all those doodles and all those drawings, I had gotten pretty good at sketching my angels. I felt like my drawing had begun to represent my experience, but the mud paintings were embarrassing. Now, after I mixed the two paints and squeezed it out of tubes, I felt I could finally express my experience. I didn't know what I was doing or how it was going to turn out. I

Celestial Door Far, *48" x 36", acrylic on canvas over wood, 1990.*

was just laying lines, laying color . . . it was automatic." ¶ That first painting was *My Seven Angels,* still one of Lakey's most powerful works—depicting the seven angels who saved his life dancing upward across the canvas with mazelike lines, countless poles of light, and a bright planet in the background. It seems a natural starting point for Lakey's artistic journey: a clear attempt to capture his first celestial experience and a thematic precursor to the Angel 2000 series. Yet for the artist himself, the act of creating the painting was an intuitive revelation. ¶ "When I started painting *My Seven Angels,* I didn't know I was painting seven angels. I was just drawing angel forms, but when I put the last angel on the top of the painting, I *knew* there were seven angels there—just like I *knew* there were seven angels swirling around me in the shower. I didn't actually count them until I was done. And I didn't know that parts of the angel forms were covered by other forms, that there was no whole angel in the painting. It happened unconsciously." ¶ Today, *My Seven Angels* hangs in the entryway of Lakey's home, a personal painting he will never sell. Although he calls it "raw" compared to his later work, he recognizes that the difference is more of technique than of essence. For in *My Seven Angels,* as in the almost 1,500 paintings he's created since, Andy Lakey accomplished what he had set out to do when he decided to become a painter: he captured his experience. "When I stood in front of the painting," he says today, "I thought, 'Some of it's here. This is how I felt . . . the angels . . . the space . . . the millions of poles of light.'" ¶ Lakey returned almost everything he had bought at the art store—thousands of dollars worth of paints and equipment—and ordered eight more doors from the lumber store. After *My Seven Angels,* he completed two very different, yet equally powerful canvases that he calls celestial views. If *My Seven Angels* is a close-up of his experience, almost as if the viewer stands "face-to-face" with the faceless angels, the celestial views are wide-angle shots in which the artist becomes a tiny, hidden angel himself, floating among vibrant, whiplike poles of light against a background of black space and distant planets. Although these views are primarily black and white, Lakey achieves a remarkable dimensionality with virtuoso line and colored shading of the thick, twisting main poles that dominate the heart of the canvases. "Those paintings were so intense," he recalls, "that they actually scared me. I felt like I was being drawn back into the experience. I had to back away from it." Lakey's next two canvases are just that—increasingly distant views called *Celestial Door Close* and *Celestial Door Far,* in which the artist imagines himself backing away from the vision, watching the cosmos through a dimensional doorway. ¶ After the four celestial

Left: Celestial View #1, The Poles of Light, *20″ x 42″, acrylic on canvas over wood, 1990. Collection of Conrad and Jeanette Will.
Right: Celestial View #2: Approaching the Poles of Light, *20″ x 42″, acrylic on canvas over wood, 1990. Collection of Conrad and Jeanette Will.

Celestial Door Close, 36″ x 42″, acrylic on canvas over wood, 1990. Collection of Conrad and Jeanette Will.

abstracts, Lakey returned again to the close perspective, creating *Angel #1*, the first painting in his Angel 2000 series. Here, as in *My Seven Angels*, he allowed the angel icon to take center stage, with writhing organic matter below it, cosmic darkness and celestial lights in the background. But whereas *My Seven Angels* achieves a sense of movement with the angels dancing upward across the canvas, a part of one angel hiding a part of another, *Angel #1* offers a single, centered angel icon, as if the artist is exploring the power of the icon itself, the power of the angel form. Painted in muted colors on an intimate panel, *Angel #1* established a style and a size that Lakey continued to explore through many of the early paintings in the Angel 2000 series. ¶ Just days after his vision of three angels in the ball of light, Andy Lakey had discovered a new artistic technique. In a span of about eight weeks, he employed that technique to create six powerful paintings—*My Seven Angels*, the celestial views and doors, the first painting in his Angel 2000 series—the beginning of a professional body of work. But as every artist knows, it's one thing to create good paintings, quite another to have them validated critically and commercially. Almost immediately after finishing his first series of paintings, Lakey's angels delivered on their promise to make it possible for him to pursue his mission.

Levitation, 58" x 32", acrylic on canvas over wood, 1990. Collection of the artist.

Once again, it began with a feeling, an unexplained urge. ¶ "I decided that I needed to go to my bank, which was right across the street from my home, and ask if I could hang one of my paintings. The manager, Linda, knew me. I was very excited about my paintings, so she let me hang three of them. Two were abstracts—celestial views—and the other was my painting of the seven angels. It turned out that an art collector from Canada happened to come into the bank that day, and Linda later told me that he stood in front of the paintings for almost an hour, studying them, the seven angels in particular. Something about that painting intrigued him." ¶ The Canadian collector— who prefers to remain anonymous—contacted an art dealer named Pierrette Van Cleve, with whom he had done business in the past. "He asked me if I'd ever heard of Andy Lakey," Van Cleve remembers, "and I told him I hadn't. So he asked me to research the artist. He was interested in commissioning him to do a big painting in his house up in Canada, and he wanted to make sure Lakey was a trustworthy, viable painter." ¶ Van Cleve called Lakey, explained that she had a client who was interested in his work, and asked him how long he had been painting. With disarming honesty, the artist replied, "About eight weeks." There was a moment of silence as Van Cleve, an Oxford University graduate who had worked with artists and collectors all over the world, tried to digest this startling bit of news. "I could just hear it on the other end of the line," Lakey remembers. "She didn't say it, but the feeling was,

Angel #667, *38" round, mixed media on wood, 1993.*

Censored Moonmates, *36" x 48", acrylic on canvas over wood, 1990.*

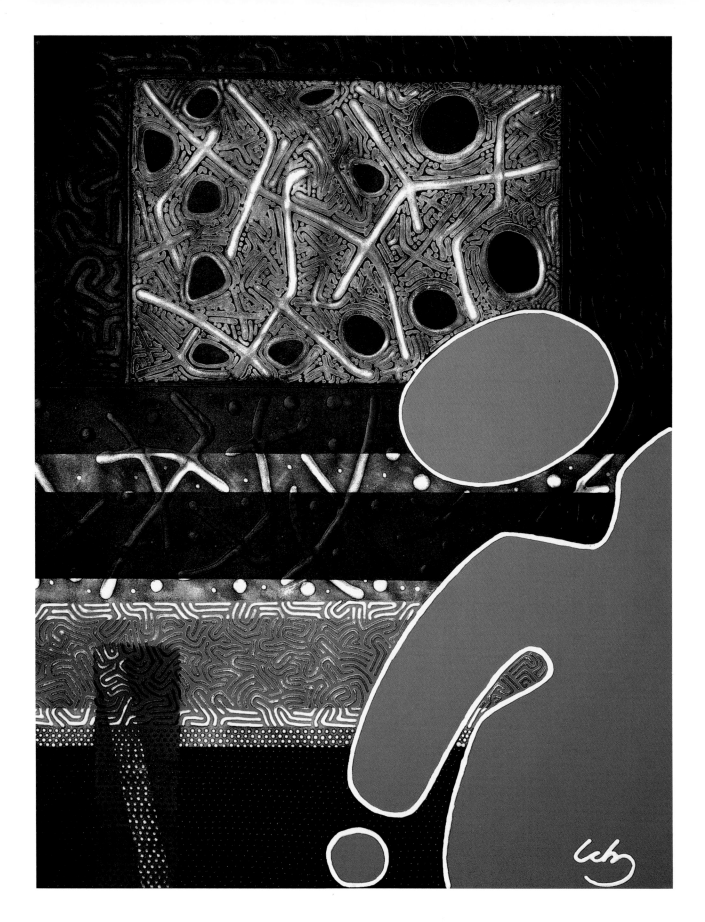

Green Man, *36" x 48", acrylic on canvas over wood, 1990.*

"His work seems to radiate love, light, and hope, awakening a deep inner knowing or memory of a glorious illumined place. It reminds us how connected we all are— that life is indeed a circle."

MELANIE LEONARD
COLLECTOR
PORTLAND, OREGON

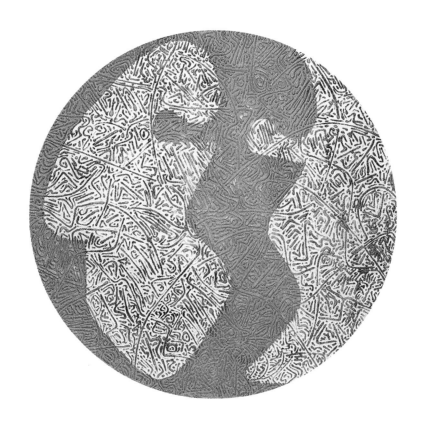

Detail from Man/Woman, *40″ x 32″, acrylic on canvas over wood, 1990.*

'Something's wrong here.'" ❡ Actually, Van Cleve explains today, "I thought this guy's either a genius or a sham, because my collector had sophisticated artistic taste. If this guy's really been painting for eight weeks, I wondered, how could he create something that would interest this collector? Who is this prodigal child?" ❡ Despite her misgivings, Van Cleve arranged to visit Lakey at his studio. "As I was driving over in my car, I kept asking myself, 'Why am I doing this?' I never go critique an artist in his studio, even established artists. Yet here I was, driving over to see a man who'd been painting for eight weeks. There was something in his voice, the way he expressed himself—even in that first conversation—that intrigued me. He projected such confidence. For years I'd been telling artists that they had to sell themselves, to be more aggressive in presenting their work to the public. Andy Lakey seemed to do that naturally." ❡ Van Cleve stopped off at the bank first, to see the paintings that had caught the eye of the Canadian collector. There her misgivings exploded in wonder. "It was unique, something I hadn't seen before—a raised three-dimensional line, as if the paint had been mixed with plastic." ❡ When she arrived at the tiny garage-studio, Van Cleve found Andy Lakey and Domonic Mongello working away, both young men with black hair slicked and swept back in classic 50's style. "It was like two Elvis impersonators creating art," Van Cleve remembers, laughing at the thought. "Domonic was writing haiku all over the walls, and Andy was creating these incredible paintings. The first thing he said was, 'Touch it! Touch it!'" ❡ Van Cleve did as Lakey urged, running her fingers over the raised outlines of the forms and the numerous curving lines within and around them. Several years earlier, while teaching art in a public school, Van Cleve had made a promise to a twelve-year-old blind boy, that someday she would do something to help bring art to the blind. Now, as she touched the art of Andy Lakey, she saw a way to fulfill that promise. ❡ "Have you ever considered sharing this art with the blind?" she asked. ❡ "No," Lakey replied. "But that's an interesting idea." ❡ As the two talked further, Lakey showed her some of his sketches and early doodles, never mentioning the near-death experience that inspired his recent work. By the time she left the studio, Pierrette Van Cleve was convinced that Andy Lakey was a serious artist, despite his lack of experience. She reported back to the Canadian collector, who gave Lakey a substantial commission to paint a triptych, a large, three-part panel, for his house in Canada. The commission was like a gift from heaven. Just a few months earlier, Lakey had left his well-paying sales job to face an uncertain financial future, but he believed in his path, despite the odds, and now a

Canine Connection, *36" x 48", acrylic on canvas over wood, 1990.*

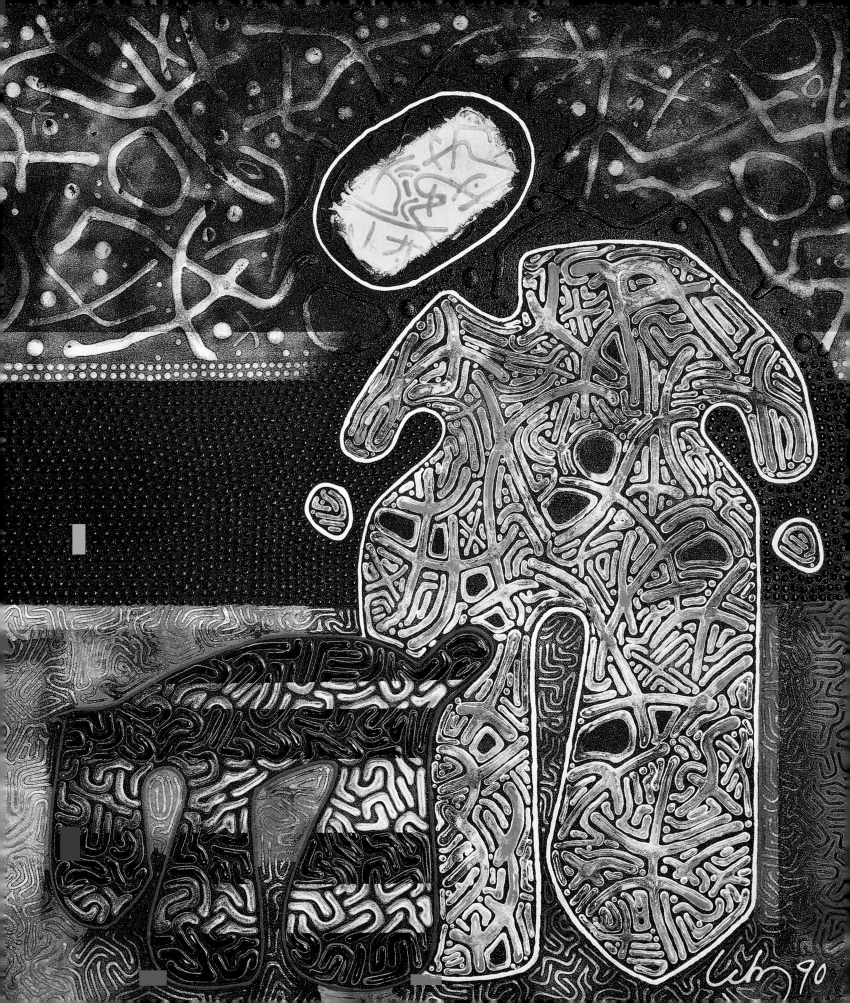

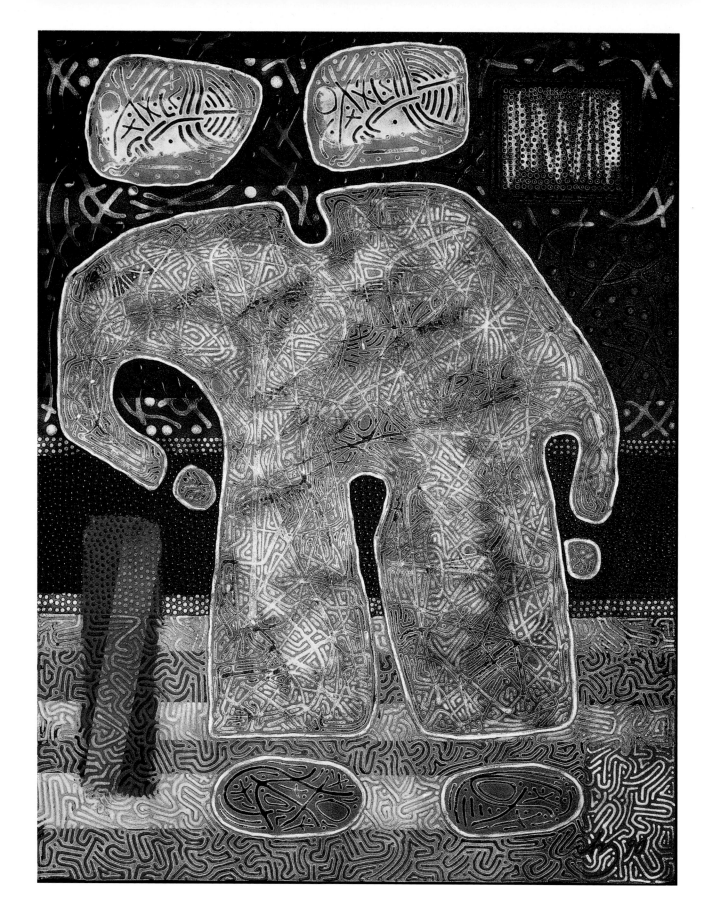

Siamese General, *36" x 48", acrylic on canvas over wood, 1990.*

collector had offered him a commission that would pay his bills for months and allow him to continue to grow and develop as an artist. ❡ The tension between the close-up of the angels and the larger view of space that Lakey explored in his first six paintings also drove the artist during the feverish period of creation that followed. As he gradually settled into the Angel 2000 series, Lakey continued to express other aspects of his experience, creating a body of work that he collectively terms his Celestial Style. There are around fifty of these paintings in all, most dating from his first year as a painter. Along with the celestial views and doors, they include a sun, a moon, abstracts of space, ocean, and earth, and several round paintings in which he imagined the interior of a pole of light, using aluminum foil, and later, mirrors, in an attempt to capture the overwhelming brightness—a precursor to his use of mirrors in the angel paintings. ❡ Most intriguing of all are the extraterrestrials—some humanoid, some animal—a reflection of Lakey's belief that he saw so many angels or souls during his experience that they must have come from planets all over the universe. With titles like *Siamese General, Censored Moonmates,* and *Canine Connection,* these are the most sophisticated of Lakey's Celestial Style, outlined in free, confident lines that create form without concern for detail, while utilizing the concept of figure against cosmic background in a manner that parallels the development of the Angel 2000 series. One of these figures, *Green Man,* is actually the front panel of a set of four paintings that, when placed together, form a spaceship in which the green voyager can gaze out into the cosmos. "The man in the space ship, the green man, is searching, cruising through the universe, trying to find the dimension that I experienced," Lakey explains. "But it's impossible. He can never get there without passing on. That's why the planets and poles of light are so muted. He can see them in the distance, but he can't reach them." ❡ Although dark in tone and raw in technical execution, the celestial paintings still stand among Lakey's most powerful works, exuding vibrant energy on several levels—the energy of size, shape and texture; the energy of a young artist experimenting with a new and unique technique; the energy of a visionary trying to capture the cosmos. "You have to realize," Lakey says, "that all my paintings are really angel paintings. Every painting has an angel, but in the celestial paintings the angels are very small, and I often hide the angels by painting them black against the black background. You have to touch them to discover them. I was trying to capture everything I saw, the way I saw it when I was a tiny form floating in the universe." ❡ The dark tones, complex textures, and solid wood foundations of the celestial

Angel #305, 8 1/2″ x 29″, mixed media on wood, 1992. Collection of the artist.

paintings—along with the similar features of the early paintings in the Angel 2000 series—allowed Lakey to pursue Pierrette Van Cleve's suggestion of painting for the blind without altering his naturally developing style. "I never really did anything different to make my paintings accessible to nonsighted viewers, but as I thought about sharing the work through the sense of touch, I realized that blind people would recognize raised shapes and patterns that sighted people might miss. That was exciting." Beyond the artistic excitement, however, Lakey saw the idea of painting for the blind as a way to keep his second promise to God, to give something back to the world. He was offered a chance to give that gift sooner than he expected. ¶ About a week after her first visit to Lakey's studio, Pierrete Van Cleve received a call from a local television station, an ABC affiliate called KGTV. A producer there wanted to discuss a story involving Van Cleve's art consulting company, which was working to allow people to experience fine art through virtual reality. ¶ "You should meet an artist I know who's painting for the blind," Van Cleve told him. She gave him Lakey's name and telephone number, and a camera crew went out to film the artist at work in his studio. Just as impressed as Van Cleve had been, the television producer quickly arranged a private showing of Lakey's work for three visually-impaired adults at Swahn Gallery, a popular art gallery in downtown San Diego. Carol LeBeau, perhaps the best-known news anchor in San Diego television, covered the showing and interviewed the visitors on-camera. ¶ "The only other art I've ever touched was sculpture, and this is—like he said—sculpture on a canvas," one of the visitors remarked as he ran his fingers over a Lakey painting. Another viewer explained that

"I thought this guy's either a genius or a sham, because my collector had sophisticated artistic taste. If this guy's really been painting for eight weeks, I wondered, how could he create something that would interest this collector? Who is this prodigal child?"

PIERRETTE VAN CLEVE

OCTOBER, 1995

Angel #1371, Self-portrait #2, *6″ x 8″, acrylic on wood, 1995.*

Angel #307, 12" x 12", mixed media on canvas over wood, 1993. Collection of the artist.

in the past she had only been able to touch the frame that surrounded a painting. When asked if she could enjoy this new art form through the sense of touch, she replied enthusiastically: "Yes, there would always be something new that I would be learning . . . something new that I hadn't discovered before." ¶ For Andy Lakey, the response of the visually-impaired viewers was a clear affirmation that he was on the right path, that he was creating something unique and positive for the world. "I incorporate something for them that you and I can't see," he explained. "So it's very interesting to see how they react, because each nonsighted viewer will experience a different painting." ¶ ABC's Peter Jennings happened to be in the San Diego studio that day. The local news producer told Lakey that although the art was interesting on videotape, the textures had to be experienced in person. When he asked Lakey if they could borrow one of the paintings to take back to the studio, the artist replied that they could not only borrow it, they could keep it as a gift. The San Diego news crew gave the painting to Peter Jennings, who carried it home

Angel #309, 12" x 12", mixed media on canvas over wood, 1993. Collection of the artist.

with him to New York City, where he presented it to The Lighthouse—a renowned center for the blind and vision-impaired—thereby establishing Lakey's tradition of donation to places of healing. ❡ After seeing Lakey's work on television, the director of the Jacqueline Westbrook Gallery in La Jolla invited him to mount a solo exhibition. By the date of the showing, August 4, 1990, he had perhaps fifty paintings: the early creations in his Angel 2000 series and a variety of works in his Celestial Style. The turnout was astonishing for a new artist; hundreds of people came, and the gallery sold every painting they had to sell. In a clear indication of Lakey's popular appeal, the first person who walked into the gallery bought the first painting she saw on the wall. ❡ It was now just ten months since Andy Lakey decided to become a painter, just eight months after the three angels appeared to him in a ball of light. In that short time, he had discovered a new painting technique that allowed him to express his own celestial experience and communicate to both the sighted and the blind. He had appeared on television across the country, and a

famous network news anchor had presented one of his paintings to a well-known institution of healing. A single commission had secured his financial needs for the foreseeable future, and he had sold every piece of art offered at his first professional showing. And all this happened with no conscious effort by Lakey, except for the daily need to create his paintings. Where others might see chance or unusual opportunity, Lakey sees divine guidance. He calls it angel power. And it was about to shift into higher gear. ¶

Angel #377, 18" x 22", mixed media on masonite, 1992. Collection of Denny Mighell.

ART FOR THE BLIND, LINES FROM THE MIND

An Interview with Pierrette B. Van Cleve

Pierrette B. Van Cleve is the founder and President of the Art Cellar Exchange in San Diego, California, a global fine art consultancy specializing in acquisitions, appraisals, and collection management. Along with more traditional services, it's the first brokerage to connect artists and art collectors on the World Wide Web, the fastest growing realm of the Internet. With multiple degrees in art, art history, and art education, as well as a designation in Art Historical Criticism from Oxford University, Ms. Van Cleve devoted much of her earlier career to art education in the museum world.

In early 1990, Pierrette Van Cleve was the first professional art expert to discover the work of Andy Lakey, a connection that proved mutually helpful and inspirational. For Lakey, Van Cleve's endorsement led to his first major commission, and her suggestion that he paint for the blind provided a focus and purpose for his textured paintings, then in the early stages of development. For Van Cleve, the art of Andy Lakey was like the answer to a prayer she had never spoken out loud, a vehicle to keep a difficult, yet heartfelt promise.

During the mid-eighties, after ten years of working in a museum, Van Cleve had taken a brief hiatus to teach art at an Iowa public school. There she met a twelve-year-old boy named Brian, who had been blind since an operation to remove an eye cancer at the age of two. "Brian came to me and expressed an interest in taking art," she remembers. "I said, 'Of course you can take art. Why wouldn't you be able to take art?' He told me that the other art teachers wouldn't let him into their class because he was blind. I said, 'Ridiculous! Come on!' And I brought him into my art class."

With her rich background in arts education, Van Cleve developed new techniques to teach the blind artist-in-training about the colors and shapes he couldn't see.

"When everybody was painting, Brian asked, 'How can you teach me about color?' So I explained to him that colors are warm and cool. I heated up certain colors and cooled down others and put his fingers in them with different grits of sand to give him the feeling of how color reacts with heat. I taught him how to paint with a measured amount of sand in his paints, so when everyone was critiquing their work, Brian would run his fingers over his paintings, because he knew that rough sands were certain colors and smooth sands were other colors.

"When we were doing still lifes, Brian would feel the still life and then go back and draw it. It was so important to him; it changed his life so much. He drew all the time—it opened up a world for him, a visual world he had never experienced before. At the end of my class, he told me how much it meant to him and how much it would mean to other blind people. 'Will you promise me that you'll do something to help the blind?' he asked. I said, 'Brian, I promise you that in my life somehow I will do something to help blind people understand and learn about art, because you've taught me as much as I've taught you.' I made that promise, never knowing. . . ."

Van Cleve's voice trails off . . . never knowing that Brian would die suddenly of leukemia in January 1987, just as Andy Lakey was beginning a new life granted him by the angels . . . never knowing that she would meet Andy Lakey and find a way to keep her promise.

"When Andy told me to touch the paintings, the first thing that came to mind was, 'My God, if I had had this technique,

think of what I could have done for Brian!' And then I told Andy about the idea of painting for the blind, and he developed it from there. That was my little legacy to Brian."

Along with the personal satisfaction she found in Lakey's early work, Van Cleve was professionally fascinated by what she saw and felt. "I left the studio that day, and I came back to my office, and I thought, 'I can't believe what I just saw.' I was very interested in it, thinking about the implication of whether I'd seen a new medium, a new technique, a new texture."

Van Cleve believes that the roots of Lakey's art lie in his childhood doodles, which he showed her that first day, when she asked him about the origins of these strange, compelling paintings. "Andy's doodles were massive webs of line—they looked like a neuron web—and as he showed them to me, they became more and more organized; they had a thought pattern to them, a beginning and an end. He would start his pencil on one part of the page and fill the page without ever picking it up, which is where he gets this command of meandering lines—from years of doing it. He has a natural talent for using line as a key unifying device, a tremendous sense of eye-hand depth perception and coordination. And he's managed to parlay that into some wonderful fine art."

Lakey's early doodles, as well as the more abstract lines in his present-day paintings, are examples of a "nonmimetic line," a form of drawing used in art therapy. Whereas a mimetic line attempts to "mimic" an actual object, such as a chair, a nonmimetic line is an attempt to represent a feeling, such as love. In this sense, Van Cleve sees a natural connection between Lakey's work and the "automatic drawing" of the Surrealists. "They would lay down on the floor with a pencil and a paper in their hand," she explains, "and they would dream; and as they dreamed they would just allow their hand to do this sort of Ouija board thing, and those drawings would be a manifestation of that nonmimetic thinking. Andy's drawings, in their intricacy, remind me of brain synapse patterns, and of course there's a certain part of the brain that's activated when you draw. It's almost as if Andy has the ability to trace those synapses by the way he draws his line, particularly in the early drawings with that random line that was just following the nonmimetic synapses of his thought. Then, of course, as that line becomes more descriptive, it turns into objects and angels."

Despite her insights into Lakey's artistic antecedents, Pierrette Van Cleve believes that a key to his success is his lack of artistic education. "Andy wanted people to experience his art, because he didn't have any preconceived notions as an artist. He didn't say, 'You can't touch my painting, because you might do this or that.' With Andy it was always, 'Touch it! Feel it! Eat dinner on it!' He had no preconceptions, and therefore it opened up a realm of possibilities.

"Whenever I talk to Andy, I think of the song from *Tommy,* the rock opera by The Who: 'See me. Feel me. Touch me. Heal me.' Once you lay your hands on somebody, you have the potential to heal that person. Once you lay your hands on this artwork, you experience it in a fundamentally different way. That's what it's about."

Computer Embryo, *40" x 32", acrylic on canvas over wood, 1990.*

Lindsay Brand was a special child who spoke in full sentences before she could walk, often expressing thoughts that were wise beyond her years. She loved art projects, too; her favorite color was purple, and everything she created had to have a heart, a reflection of her own sweet and loving personality. Her parents, Penny and Richard, delighted in their only child, but in 1988, just before Lindsay's third birthday, their delight turned to nightmare when she was diagnosed with a brain tumor. During long, difficult surgery, doctors removed about 90 percent of the tumor, which they discovered to be malignant. After weeks of radiation therapy and extended chemotherapy, Lindsay's condition improved, and the Brands began to believe that their little girl might survive.

Then, in July 1993, when Lindsay was seven and one-half years old, the cancer returned. This time it was worse; it had spread into her spine, and the doctors informed Lindsay's parents that it was only a matter of time before the cancer claimed her. A registered nurse with many years of clinical experience, Penny Brand decided to take Lindsay home and care for her herself. Though the terminal diagnosis was devastating for her parents, Lindsay showed no fear at all. She seemed completely at peace, as if she could already see the other side and knew it was a realm of goodness and wonder, a place beyond sorrow. That was the impression she gave to Penny, at least, but one day she decided to let her mother in on the details.

"I have something to tell you, Mommy," she said. "You have to record it, because no one's going to believe it."

Wondering what this was all about, Penny got a tape recorder and listened in amazement as her daughter spoke of her experiences with the angels. They always wore white she said; they were very pretty and they spoke to her very softly. There was another beautiful, soft-spoken lady, too, dressed in a blue cape and a blue veil. She was the Blessed Mother.

Penny Brand didn't know what to think. She had been raised a Catholic, but she'd struggled with her beliefs for years, and the struggle had intensified since Lindsay's original diagnosis. Though she'd talked with her daughter about Catholicism, the images and ideas that Lindsay described were much more vivid and unusual than anything Penny had ever said. They didn't come from books, and they definitely didn't come from Richard. He had been raised in the Jewish religion, and he felt uncomfortable about all this talk about the Blessed Mother. Yet Lindsay spoke of her experiences so calmly, so matter-of-factly, that both parents couldn't help but wonder. Could it be real? Was Lindsay really being visited by the angels and the Blessed Mother, preparing her for death?

Penny Brand wanted to believe. She really did. But she was too much of a rationalist to accept it. She needed proof.

Lindsay died on November 9, 1993, a month after her eighth birthday. She was buried four days later, on the thirteenth. For Penny Brand, the next year was full of darkness, grief, and depression. The only light seemed to come from the angels, and she found herself reading about them and looking for angel art. She was particularly taken by the famous anonymous painting, *The Guardian Angel*, which portrays an angel flying over a city and holding a child in her arms. The curly-haired child looked a lot like Lindsay.

One day, about a year after Lindsay's death, Penny noticed

an ad for a store called Angel Wings, right in her hometown of Scottsdale, Arizona. She drove straight to the store, where, surrounded by angels, she felt a sense of peace that she hadn't felt in a long, long time. She struck up a friendship with owner Cathy Stuart, and in the weeks that followed Penny found herself drawn to Angel Wings again and again, especially on Saturday afternoons. Richard worked on Saturdays, and Penny didn't like to be home alone.

At first Cathy Stuart helped Penny find items with the image that stirred such a chord in her spirit, the guardian angel carrying a child that looked like Lindsay. Then one day, Cathy began to talk about the art of Andy Lakey. Andy had just agreed to allow Cathy to sell his paintings, and she had a few pieces on hand, all light, pastel colors with painted frames. Penny thought the paintings were nice, but they didn't affect her in the same way as the angel holding the child. However,

when Cathy explained that she could send Lakey a photo of Lindsay, and he would try to paint whatever he felt from her energy, she decided to order a small 8" x 10" painting. She assumed the colors would be light pastels, and she specifically requested a silver frame. In May 1995, Cathy Stuart sent the artist a photo of Lindsay taken shortly after her first chemotherapy sessions and an anniversary card Lindsay had written to her parents a month before she died.

Several weeks later, when Penny arrived at Angel Wings to pick up her painting, she was a little disappointed. It didn't have the silver frame she'd requested; in fact, it didn't have a frame at all, and the colors were so much darker than what she expected. Lots of purple . . . she stopped for a moment as it registered. Purple—Lindsay's favorite color. Penny turned the painting over and gasped in astonishment when she discovered that Lakey had drawn a heart on the back, just as Lindsay had

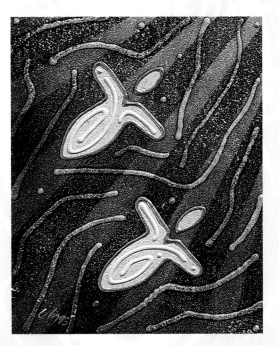

Angel #1309, 8" x 10", acrylic on wood, 1995.
Collection of Penny and Richard Brand.

drawn a heart on every card or picture she had ever made for her mother. But it was the angel number that really sent the message. It was *Angel #1309*. Lindsay Brand was buried on the thirteenth and had died on the ninth.

Standing in Angel Wings, Penny Brand began to weep— tears of sadness, tears of joy. This was the proof she had wanted. It was Lindsay's way of saying, See, Mommy, I was telling the truth. I really am with the angels.

Cathy Stuart called Lakey from the store, and he described to Penny his experience in creating the painting. "When I taped the card and Lindsay's picture behind the canvas, I felt enormous energy," he said. "I tried to create a painting in a silver frame, but it just wouldn't work. I felt like Lindsay didn't want to be confined by the frame. So I created it without the frame." Lakey also remembered going to get the purple paint. "I had never done a painting with so much purple," he explained.

As for the heart, Andy just "felt" that Lindsay wanted a heart on the back. He had done that on other paintings, but it's not something that he does regularly. And the number came from feeling as well. As he progresses through the Angel 2000 series, Lakey numbers the paintings more or less in sequence, but he allows himself a certain freedom to go with his feelings. He had no knowledge whatsoever of Lindsay's date of death or burial, but he "felt" that the painting should be #1309.

For Penny Brand, the angel painting was a clear message from Lindsay, the proof she had been looking for. "Andy helped me to believe that what she was saying was true. The painting has brought me peace."

Penny also believes that there is another meaning behind Lindsay's attempt to communicate through Andy Lakey—a greater message that might emanate far beyond her own family. "Lindsay wants her story to be told," Penny says, "for three reasons. To create more awareness of the medical condition, which has now become a leading cause of death among children; to create spiritual awareness of the hereafter; and to help other parents and children."

Penny Brand has hours of tapes in which Lindsay talks about her experiences with the angels and the Blessed Mother, but in a small way perhaps, through this profile and through the hands of Andy Lakey, Lindsay Brand *is* telling her story.

At his first solo show in La Jolla, Andy Lakey made two interesting and important connections. A Catholic Church official, impressed by these textured angels that seemed so different from traditional representations of celestial beings, sent some photos of the paintings to a friend at the Vatican who happened to be a secretary to Pope John Paul II. When Lakey received an official request to see one of the actual paintings, he sent the first painting in his Angel 2000 series, *Angel #1,* with a note offering it as a gift to the pope. Almost a year later, in June 1991, the artist received a letter from the Vatican Secretariat of State, formally accepting his gift of *Angel #1* to Pope John Paul II. The first painting of his Angel 2000 series—the series he had been told by the angels to create—was in the collection of one of the world's most prominent spiritual leaders. ● Also among the visitors to the gallery were friends of singer Ray Charles, and after experiencing the paintings themselves, they gave Lakey the number of a member of Charles's staff. Ray Charles was scheduled to perform in San Diego just four days after Lakey's solo exhibition, and a meeting was arranged for the artist to present one of his touchable paintings to the singer between shows. ● Lakey and Domonic Mongello went to the concert and brought one of Andy's celestial paintings, *Toxogon 200 Million B.C.* Lakey had chosen this painting specifically for Ray Charles because, while it had little color, it had more texture than any painting he had yet created, with thousands and thousands of raised dots representing the poles of light from his near-death experience. Charles's security people led them to a backstage dressing room where Lakey was instructed to leave the painting until after the show. Then they handed Andy and Domonic two front row tickets for the concert. "Ray Charles's performance really touched me," Lakey remembers. "It was soulful . . . spiritual . . . magical." ● Afterwards, Lakey went back to the dressing room to present the painting. This was a special opportunity. He was creating an art form that could be experienced by the blind, and now he was about to share that art

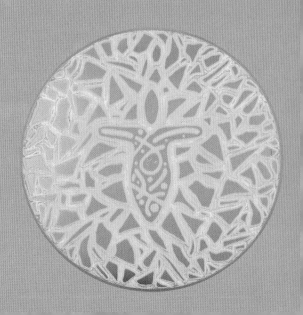

C H A P T E R F O U R

Friends in High Places

with Ray Charles, a blind musician of unquestioned integrity and talent. ¶ "I set the piece on the floor, leaning up against the wall," the artist later explained. "Ray knelt in front of it. His fingers spread out over it, gently caressing the ridges, the contours, the bumps. I watched his serious face. I'll never forget the moment I knew he could 'see' and understand my work. His face seemed to become one huge grin. It was wonderful." The wonder became complete when Charles turned to Lakey and said, "This art is incredible. I love it. I want you to share this with the world." ¶ Every artist wants to share his art with the world, but to Andy Lakey—that night, in that place—there was something compelling, almost mystical, in hearing those words from Ray Charles. The three angels in the ball of light had conveyed that certain people would come into Lakey's life and guide him along his path. Ray Charles was one of those people. But how to follow his guidance? Lakey contacted organizations for the vision-impaired, but he found it difficult to penetrate the layers of bureaucracy. He contacted corporations, too, but they had their own donation programs. Finally, he decided to contact other people like Ray Charles, celebrities who had a reputation for generosity and social involvement, people who were making a difference in the world. ¶ In the fall of 1990, Andy Lakey identified about ten well-known individuals who were active in charitable work and wrote to

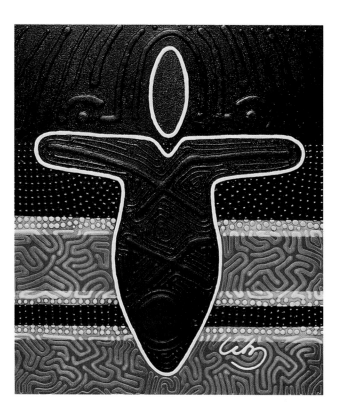

Angel #1, *18 1/2" x 22", acrylic on masonite, 1990.*
Collection of Pope John Paul II.

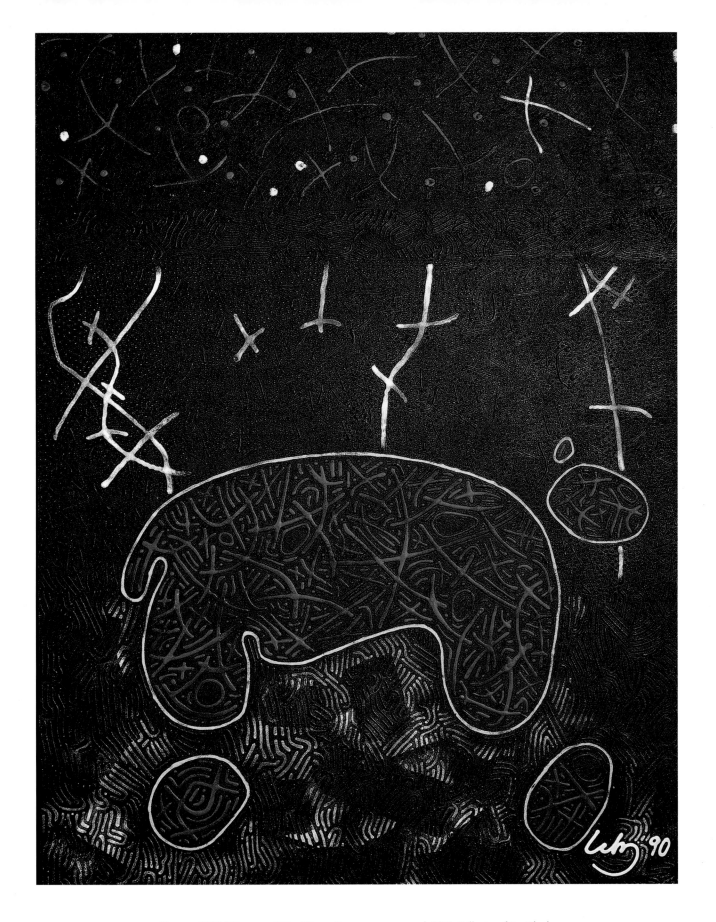

Toxogon 200 Million B.C., *36" x 48", acrylic on canvas over wood, 1990. Collection of Ray Charles.*

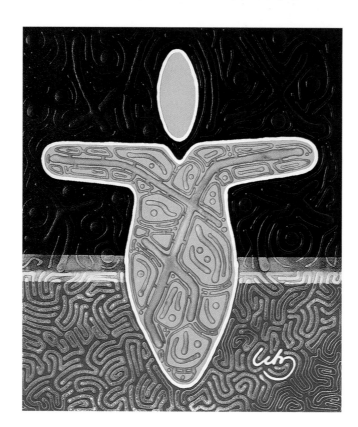

Angel #2, 18 1/2" x 22", acrylic on masonite, 1990.

them, describing his new touchable art and offering them a painting, either for their own collection or to donate to a place of healing. This was one of the few times in his career that he made a conscious effort to spread the word about his work, and the response was all he had hoped. By November, Lakey had received gracious letters of acceptance from former president Jimmy Carter, golfer Arnold Palmer, and actress Lee Meriwether. Others soon followed, but these first three provide an unusual cross section that typifies Lakey's celebrity collectors, representing the worlds of statecraft, sports, and entertainment. ¶ Jimmy Carter hung *Angel #3* at the Carter Center in Atlanta as a reminder "that faith, compassion and love are the infinite resources that fuel our work for peace." Arnold Palmer ended up keeping the first Lakey painting for his own collection, with a promise from the artist to give another painting to the Arnold Palmer Hospital for Children and Women in Orlando, Florida. Lee Meriwether donated a painting to the Blind Childrens Center in Los Angeles, a preschool that prepares visually impaired children for first grade, a special place that has become Andy Lakey's favorite charity. ¶ When Meriwether first received Lakey's letter describing the durable, three-dimensional textures of his work, she was immediately struck by the potential for

"The *Angel* by Andy Lakey reminds us that faith, compassion and love are the infinite resources that fuel our work for peace."

JIMMY CARTER
JANUARY 31, 1992

Angel #3, *18 1/2" x 22", acrylic on masonite, 1990.*
Collection of President Jimmy Carter.

Angel #675, *20" round, mixed media on wood, 1993. Collection of Jerry and Sho Simon.*

reaching young children, who could experience the painting with their hands rather than their eyes. She discussed the project with Midge Horton, Director of Development at the Center, and together they came up with a striking and original idea: perhaps the artist could create a painting that would actually be used as an educational tool. Lakey did just that, creating a unique "learning painting" with raised letters, numbers, shapes, and simple words like "Mommy," "Daddy," and "Love." The painting is titled *Searching for the Three,* and that's just what the children are invited to do, search for the small numeral among the other textures. It was an immediate success. "During the dedication ceremony," Meriwether remembers, "the photographer had a difficult time getting the children to turn toward the camera, because they were so busy touching the painting." ¶ After the ceremony, the painting was hung in a hallway, low enough for the children to touch easily every day, right next to a door leading out to the playground. According to Horton, after five years of being handled daily by preschool children, the painting looks just as it did on the day it was hung—an impressive testimony to the durability of Lakey's textured technique. ¶

Lakey's experience at the Blind Childrens Center opened up a new world for him, the world of children eager to experience life—and art—in all its myriad wonders. He began to visit schools, where he would blindfold the sighted students and allow them to experience the paintings the same way the blind children had experienced them, through the sense of touch. "It's such a joy to see kids react to my work," he later said. "They love to touch the paintings." For a man who had struggled for years with the inner hurt of his own difficult childhood, the time spent sharing his art with children was a healing and learning experience. But more than that, Lakey was keeping his second promise to God, the promise to do something to help others. He knew that he had been granted a special power in his hands, and he considered it an almost sacred responsibility to share the fruits of that power with others. In 1993 the artist expressed his new-found connection with young people in the terms of a former drug user: "What gets me high is talking to kids . . . to teach them how to be a responsible person. And I'm learning. They're teaching me how to talk to them." ❡ As Lakey's charitable efforts continued to expand, he realized that he had to formulate a definite policy. "I was receiving so many requests," he explains today, "that I could have given away every painting and still not had enough. Obviously I couldn't do that, but I wanted to donate a good percentage of my work. Ten percent seemed like too little. So I decided to donate 30 percent of everything I produced each year." Today, Lakey still adheres to this generous policy, but he receives so many requests that he has had to create a waiting list for charitable organizations. ❡ Although Andy Lakey's program of charitable donation grew out of his genuine, heartfelt desire to share his paintings with the world, it was also further affirmation of his philosophy: "The more you give, the more you get, the more you have to give." His initial celebrity contacts led to more contacts and more exposure for his art. In early 1991, Lakey was asked by San Diego mayor Maureen O'Connor to present a painting to singer Stevie Wonder, as a gift from the people of San Diego in appreciation for Wonder's performance at a fund-raiser for Young at Art, a community-based program that encourages children to explore their talents in art, music, and dance. Lakey created a special angel painting for the famed singer, and like Ray Charles, Wonder was delighted by this new art form that he could experience with his hands. "He didn't want to leave the stage," Lakey remembers. "He just kept holding the painting, touching it, exploring it." ❡ While his charitable donations and celebrity connections put his work in the public eye, Lakey was also gaining attention through more traditional

artistic channels. The Weston Museum of Fine Arts in Vallejo, California, made arrangements to purchase three Lakey paintings in December 1990, including *Angel #2*. Two months later, the Riverside Museum of Art acquired *Angel #9* for its permanent collection. Galleries contacted the artist regularly, offering to represent his work, and it was a special satisfaction that some of the galleries that now sold his paintings were those that had rejected his drawings just a few years earlier. "It wasn't really an 'I told you so' situation," Lakey admits, "because the sketches I sent them were pretty amateurish—just quick drawings on yellow notebook paper. It was actually kind of funny that I even thought they would consider them. The truth is that my artistic ability reached a whole new level after I was hit by the ball of light." ¶ Lakey's growing network of galleries brought his art to a wider circle of collectors, reaching beyond the rarefied air of the rich and famous. It was the next step in a grass-roots movement that began in the earliest stages of his career, when he sold his first paintings to friends and neighbors who stopped by the studio in his garage. Despite his appeal to celebrities, Andy Lakey has always considered himself an artist of the people. "I'd give my art away," he says today, "if that's what it took to get the paintings into people's hands. That's what it's all about. I want the art out there where it can be touched and seen and experienced." ¶ After his early experimentation with celestial abstracts and space creatures, Lakey was now focusing almost entirely on the Angel 2000 series. *Angel #4*—a large 3' x 6' panel with multiple angels ascending through poles of light—is a notable exception, but most of the early angel paintings follow the style established by *Angel #1*, with muted tones and a single icon centered on an intimate panel, as if Lakey is still testing the power of the icon and the raised patterns within and around it. *Angel #26* and *Angel #38* offer the most dramatic examples of this approach, the first a black panel except for the white outline of the angel and the artist's signature, the other precisely the reverse, white with black outline and signature. ¶ Pierrette Van Cleve, who saw some of Lakey's early angel paintings as well as his celestial works, was struck not only by his three-dimensional textures but also by the keen sense of design he displayed in organizing those textures. "Like a Louise Nevelson relief," Van Cleve wrote, "Andy Lakey extends sculptural relief to the concept of a total environment. . . . He aims at organizing space without moving it—as a result you are presented with work that feels timeless. . . . His pieces present an ever-changing view to the spectator, who then participates in the artistic creation." Though Van Cleve was writing about Lakey's early work, particularly his Celestial Style, her

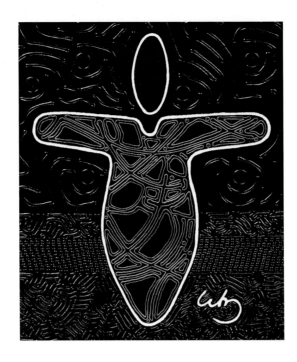

Angel #26, *18 1/2" x 22", acrylic on masonite, 1990. Collection of the artist.*

perceptions also describe the artist's continuing development in his second year of painting. Still relatively unconcerned with color, Lakey focused on design, "organizing space" in Van Cleve's terms, in a way that would draw the "spectator," whether through the sense of touch or the sense of sight, into the painting. ¶ The key to this rapidly developing sense of design was Lakey's decision to use the angel icon not only as a focal point but as a flexible element in his treatment of positive and negative space. *Angel #198,* completed in 1991, balances 158 angels flowing together on a 3' x 4' panel, while on the other end of the dimensional perspective, *Angel #200* features 29 angels, with shadow angels behind them, on an intimate 12" x 12" canvas. These paintings seem to be a turning point, as if the artist proved to himself once and for all that he could control the icon he had created and manipulate it for the greater good of the art. Although the real angels that he met during his near-death experience were still the inspiration behind every creation, after two years of painting, Andy Lakey had begun to think more like an artist. ¶ With this clearer sense of artistic self came a greater appreciation for other artists; Lakey began to make up for lost time and educate himself. Though he had never heard of Louise Nevelson before Van Cleve compared him to her, he has

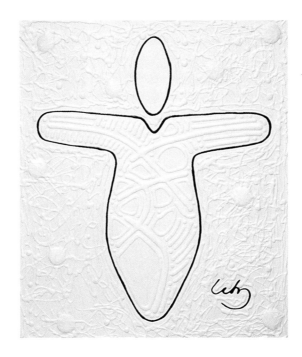

Angel #38, 18 1/2″ x 22″, acrylic on masonite, 1990. Collection of Greg Baker.

since become well-acquainted with Nevelson's work, and he too experiences a deep sense of recognition, a kinship with a woman who many consider to be among the most innovative artists of the twentieth century. He sees the connection with Keith Haring, as well, and with earlier artists like Jackson Pollock and Paul Klee. Yet of all the artists of the past and present, it is Pablo Picasso who has always offered Andy Lakey the greatest inspiration and guidance. ¶ Perhaps it is their shared ancestry, for, like Picasso, Lakey's grandparents left Spain for France, and the family has always considered themselves more Spanish than French. Or perhaps it is simply that Picasso represents everything that an artist should be. Lakey himself can't explain it. "I feel guided toward Picasso," he says simply. "I don't know why. I love his work, but it's more than that." Whatever the reasons, Lakey's "Picasso connection" has taken on a mystical dimension for the artist. When he and Domonic Mongello first began to build his studio, one of the art books they bought was *Picasso's Picassos,* a study of the "secret" personal paintings that the great master kept for himself. Early in his career, Lakey happened to place the book under his work table, and he found that he got a different feeling as he painted. "It's wild, but when I removed the book I didn't get the same

feeling. The art just wasn't the same. Even to this day, I have to have the book there when I paint." ¶ The most important lesson that Lakey drew from Picasso, however, was the discipline of daily artistic creation. Two thousand paintings on the same theme over a ten-year period is daunting, but Lakey proved capable from the beginning. While his first painting, *My Seven Angels,* took almost three weeks of concentrated effort, the paintings that followed flowed out of him like a tidal wave. He began to work on multiple canvases simultaneously, first two at a time, then three or four or five, a pattern that has continued until today, when he may work on as many as thirty or forty paintings, moving from one to the next. Lakey credits his angelic guides for his creative inspiration, but he also points to the earthly energy he brings to his art. "I knew the angels were there for me, and I trusted that they would continue to guide me. But they didn't put paint on the canvas. I had to work very hard at my art." ¶ Lakey makes it clear, however, that working hard meant putting in the hours, not necessarily struggling with issues of technique and artistic development. From the moment he began to create *My Seven Angels,* when he discovered the right mixture of paint and began to apply it from tubes, the artist entered a strange, mystical world of spontaneous creation: "It's difficult to explain. It's almost as if I'm not really painting. I'm participating. I take the pencil and I draw the angels; I take the tube and squeeze out patterns, and consciously I know what I'm doing. But it's almost as if I'm having an out-of-body experience, as if I'm watching myself paint. It's really very exciting to see how it turns out. Look at the patterns. People always say, 'It's so perfect . . . do you plan it?' I do it in seconds; I don't even think about it. There's an even number of lines and curves, the dots are placed like they're supposed to be there, it's balanced, but I don't even pay attention to it. I just go from one line to the next. The angels are the same. I sketch them where I know they're supposed to be. I never sit back and say, 'Okay, this painting's going to have three angels ascending to the left.' The angels go where they want to go." ¶ In August 1991, actor Ed Asner—one of the humanitarians who Lakey had contacted—donated *Angel #4* to the Jules Stein Eye Institute at the UCLA Medical Center. Three years later, this painting would "speak" to Matthew Tash, offering words of comfort as the eleven-year-old boy prepared for eye surgery. At this point in Lakey's career, however, such whispers of miracles were still in the future; it was the powerful imagery of the art itself that spoke to those who saw *Angel #4.* ¶ "The image of the angel has always reminded me of the freedom of the human spirit," Asner said, "the goal of aspiring for a higher

Angel #200, *12″ x 12″, acrylic on canvas, 1991. Collection of the artist.*

Overleaf: Poles of Light Close, *40″ x 32″,*
acrylic on canvas over wood, 1990.

plane. The angel painting expresses this ideal by possessing beauty that can not only be seen but literally 'touched' as well. How wonderful that Andy Lakey has created a means to elevate his art, and us with it, to that higher plane." ¶ The most remarkable aspect of Lakey's early success is that he never told anyone—except his friend Domonic Mongello—about the story behind his art. No one else knew of the angels in the ball of light or the angels who had saved him in the shower. No one knew of the drug use. Lakey's early collectors responded to the art itself, the spiritual power of Lakey's touchable angels. ¶ By late 1991, in the midst of an astonishing series of celebrity connections, Andy Lakey was clearly on the way to success as a painter. Only two years had passed since his thirtieth-birthday decision to quit selling cars and become an artist, and he had already proved beyond a shadow of a doubt that his "early mid-life crisis" had been a good, strong step on a road that was right and true. Yet there was still something missing from his life, something he couldn't quite touch. Despite all the love and joy he had given to others with his paintings, Andy Lakey felt very much alone. Not in a social sense, but in a spiritual sense. Young, attractive, and successful, he knew it was time to find a partner on the path. And as they had done from the beginning, the angels pointed the way. ¶

"Every time I look at the *Angel* by Andy Lakey, I think inspirational thoughts.... Who better than an angel to represent eternal peace?"

GLORIA ESTEFAN

OCTOBER 27, 1992

Angel #50, *18 1/2" x 22",*
mixed media on masonite, 1992.
Collection of Gloria Estefan.

Museum TV 1963, *36″ x 48″, acrylic on canvas over wood, 1990. Collection of Carina Woorich.*

TO FLIT, TO HOVER, TO DO GOOD

An Interview with Edward Asner

Ed Asner acted his way into the hearts of America with his role as Lou Grant on The Mary Tyler Moore Show. *He won three Emmys for his work on the show, as well as two for the same role in the dramatic series* Lou Grant *and two others for his roles in* Rich Man, Poor Man *and* Roots. *Along with his acting talents, Asner—who served as two-term National President of the Screen Actors Guild—contributes his formidable energy to a variety of social, political, and charitable causes.*

As an actor with a reputation for social and political activism, Ed Asner is besieged by requests for his time, his money, or both. "They come over the door, they come through the door, they come under the door," he says, with his trademark, dry delivery. Yet, when he received a letter in 1990 from an unknown artist named Andy Lakey—describing a new art technique aimed at the blind and asking Asner to donate a painting to a place of healing—Asner responded positively, ultimately donating *Angel #4*, Lakey's largest work at the time, to the Jules Stein Eye Institute at the UCLA Medical Center.

What caught Asner's attention? Why did he decide to meet the artist and pursue what he himself terms a "bizarre connection"? Today, some five years later, Ed Asner offers insights that shed light not only on his own connection with Andy Lakey, but on the whole astonishing series of connections that the artist made with well-known people during the early years of his career. First and foremost, Asner says, he was drawn to the mission that Lakey presented in his letter, the creation of "art that was primarily designed for blind young people. To me that precluded any doubts I had about meeting him." But beyond the essential goodness of Lakey's mission, Asner—a man who has not only survived but managed to rise above the rough-and-tumble world of Hollywood infighting—also found the artist's personality compelling:

"Andy has wonderful hubris. He's just not a person who takes no for an answer, and with this inordinately positive approach he has, it's a combination that's pretty hard to resist. The bottom line, thank God, above all, is that he has the talent to back it up.

"He presents each situation like, 'I need you, but if you don't do anything don't worry, because we'll get it done without you.' I think he's got a perfect combination of enormous confidence, of talent, of a very worthwhile goal for his art, and then an independence. There's always something to be said for the person who pitches you and says, 'I need you, but if you dare to say no, it won't mean anything to me.'"

Asner genuinely enjoys Lakey's art and has a Lakey angel hanging in his production office. However, like many others, he finds it difficult to express what it is about the painting that appeals to him. "I like it," he says simply. "I like it a lot. There's definitely a healing part of it; it's soothing to my eyes . . . the three-dimensional aspect, maybe that's what gratifies me."

When Asner first met Lakey, the artist had not yet revealed the story behind the paintings. And when the story did come out, Asner says, "It didn't register very high on my personal Richter scale. If his art is the result of this experience, then I'm glad he went through it." Yet when he was interviewed for a television feature on Lakey's work—for the syndicated show *Lifestyles with Robin Leach and Shari Belafonte*—Asner spoke from the heart on the deeper transformational aspect of Andy's experience: "To hear how much else he donates and the standard he employs in terms of thirty percent of what he makes,

that was one hell of a near-death experience he had. . . . I'm sure there are a lot of individuals who have had near-death experiences, but once they're out of the foxhole, they somehow forget the pledges and the promises they made. It's nice to know that Andy has kept his."

While drawn primarily to Andy Lakey's mission and the quality of his art, Asner and Lakey share another "bizarre connection" that they have never discussed. Just as Lakey's spirit left his body while he lay dying in the shower, Ed Asner also had an out-of-body experience when he was a boy of around eight or ten, though his was fully conscious and unrelated to death or injury. "My anima, my soul, a shrunken little dwarf type creature, left my body," he recalls. "It hovered in the air and wanted the automaton of my shell, my corporal form, to come along, and commented on what I looked like. I realize that somebody else might consider it delusional on the part of a child."

Whereas Andy Lakey's out-of-body experience totally transformed his life, Asner's experience had little effect, at least on a conscious level. "I think it scared the heck out of me," he admits. "I always regret that I didn't come to rely on wiser heads who would counsel me to better understand it. . . . It was so long ago, and I didn't confide in anyone. I probably worked very hard so it would never happen again."

Although he professes to be unaware of the renewed interest in angels during the last few years, Asner offers an insightful, well-considered explanation for why more and more people may be turning to angelic guides:

"It's probably far too difficult for most people to prove there's a God, seeing the excess that Man indulges in to deny God. Maybe the resort to angels is that something makes the way between Man and God more peaceful, more practical. The energy force that dominates Man—which Kirlian photography demonstrated—the out-of-body experiences that I and many others have had . . . maybe angels represent that direct, clean, ungravity-bound existence that we all long for: a freedom to flit, to hover and do good."

Andy Lakey and Ed Asner at the Jules Stein Eye Institute, UCLA Medical Center, August 1991.

God works in mysterious ways, and so do angels—messengers of divine guidance. Andy Lakey felt he needed to buy a couch and ended up with a new art technique. He decided to hang his first paintings in a bank and ended up with a substantial commission and national television coverage. He wrote letters to a handful of celebrities and ended up connecting with famous people all over the world. So it's hardly surprising that when the time came for Lakey to meet a special woman to share his life, she would come to him through a car wash. "I'd been going to this car wash for several years, and I'd grown friendly with the owner, Don Ford. One day, Don called me and said, there's someone I want you to meet, a lady named Chantal." Chantal was a high school teacher, working in the desolate desert town of Brawley and spending her weekends in San Diego. "I was in a period of my life when I was really feeling lonely," she recalls. "I had met a lot of people, but nobody I could connect with. I remember the day that I met Andy I felt uplifted and happy. . . . I felt a connection, a special warmth in his hand." Andy expresses a similar connection in characteristically visual terms: "The first time I saw Chantal, it was like she was surrounded by light." The sense of already knowing this "stranger" was so powerful that he did something totally out of character, something he had never done with another woman before, even in jest. He asked her to marry him—on the first day they met. "We were looking at one of my paintings. I put her hand on the raised textures, and her hand emanated a powerful force. I merged with her, and I knew at that moment that she was my soul mate. I said, 'You know what we should do? We should get married.'" Naturally Chantal laughed it off, but she agreed to meet him for dinner that evening. Over blueberry pie, Andy drew a sketch of an angel on the back of a place mat and gave it to her, saying, "This is my angel, and you're an angel, and I'm drawing this especially for you. I'm going to sign it, because someday I'm going to be a very famous artist." Chantal took the drawing, folded it up, and put it

Earthly Angel

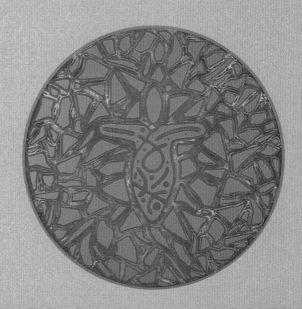

into her wallet—where she still keeps it today. "I'm a very skeptical person," she says, "and it was strange what I felt, because I knew this guy was telling the truth." ¶ It was the beginning of a whirlwind courtship, played out between the desert and the sea. On Christmas Day 1991—a month after they met—Andy and Chantal were married, with Domonic Mongello as the best man and Chantal's two daughters from a previous marriage as witnesses. Today, both of them admit that it was a wild thing to do, but the sense of connection was overpowering. "Chantal was supposed to come into my life," Andy says seriously. "We were destined to be together." ¶ It was only gradually that they discovered the depth of that destiny. After their marriage, the couple continued to live apart during the week, with Chantal teaching in the desert and Andy painting in his La Jolla studio; yet as they got to know each other better, they found a remarkable series of shared experiences. Both of their mothers had been born in France, and Andy and Chantal had both lived in France between the ages of two and five. Both of their fathers were in the U.S. Air Force, and they had been stationed at Castle Air Force Base in Merced, California, at the same time—where Chantal often went swimming in the pool in which Andy almost drowned as a child; perhaps she was even there that day. As adults, they lived at the same time in two different San Diego neighborhoods, and in both neighborhoods they went to the same veterinarian, the same post office, the same bakery, the same grocery store, the same everything—all before they ever met. But these were only the surface connections. The strongest connection lay deeper. ¶ When they were married, Chantal knew nothing of Andy's near-death experience or his vision of the angels in the ball of light. At first she didn't think much about his angel paintings, either, because many of the early works she saw reflected his more abstract Celestial Style. Yet as she returned to San Diego each weekend, she began to realize that Andy was painting the same angel shapes over and over again, in different designs and arrangements and sizes. She saw the paintings evolving, too, as the artist began to use more colors . . . soft pastels . . . pink and salmon, pale green and yellow. Although he had experimented with mirrors early in his career, he now began to use them extensively to capture the other-worldly light he had seen. "The paintings really came alive," Chantal remembers, and as they came alive she found herself asking a question that had been lingering in the back of her mind: "Why do you paint these angels?" ¶ "That's when he told me about his angel experience, and I said, 'My God! I had hundreds of angels surrounding me on a cliff once,' and I told him my story about how I lost Dale." ¶

Chantal's angel experience had occurred many years earlier, and unlike Andy's encounters, it was a mixed memory—full of sadness because she had lost the man she loved, yet full of hope and wonder because the angels had saved her from certain death. She had never told anyone about it, and she had never met anyone else who had encountered angels. Andy had mentioned his own experiences briefly to Domonic, but he, too, never spoke of them to others and had never met another person who'd encountered angels. Now he had—and he was married to her. It was an incredible moment: husband and wife, married one month after they met, and just getting to know each other, discovering that they shared a deeper bond than they had ever imagined, a bond consecrated by the angels. ¶ "It was overwhelming," Chantal says simply. "It made the connection even stronger, helped us relate to each other even more and more and more." ¶ Andy, too, was overwhelmed. Yet as he looks back over the changes in his life since he met Chantal, he's convinced that it was all divinely guided. "She has these angels; I have these angels. You get these two groups of angels working together, and they just push us forward." ¶ If we are to divide Andy Lakey's life and career into periods, his marriage to Chantal marks a new period on every level: personal, artistic, professional. On a personal level, he found a sense of love and family that he had been searching for all his life. Although he prefers not to go into details, Lakey's birth family would be termed dysfunctional and abusive by most experts. Chantal was also the product of a dysfunctional, abusive birth family, as well as a failed marriage. Now they worked together to create their own nuclear family, as Chantal's older daughters were soon joined by two baby sisters, first Joy, then Cora. ¶ Fatherhood changed Andy Lakey just as it has changed many men before him. Although he had always had strong powers of concentration, he became even more focused, more rooted, more prolific. Chantal had complications with both pregnancies, and with Cora her condition become so serious that she had to spend the last eight months in bed. Baby and mother almost died during delivery, yet the angels watched over them and both survived, happy and healthy. Andy was there for Chantal every minute, moving out of his studio to work in their garage so he could care for her. Despite taking over many of the domestic chores, he maintained an incredible level of artistic production, staying right on schedule for his Angel 2000 series. ¶ More remarkable than his productivity, however, was his artistic development. Lakey's increased use of color and mirrors that brought the angels to life for Chantal also made the paintings come alive for others, marking a new level of public appreciation for his art.

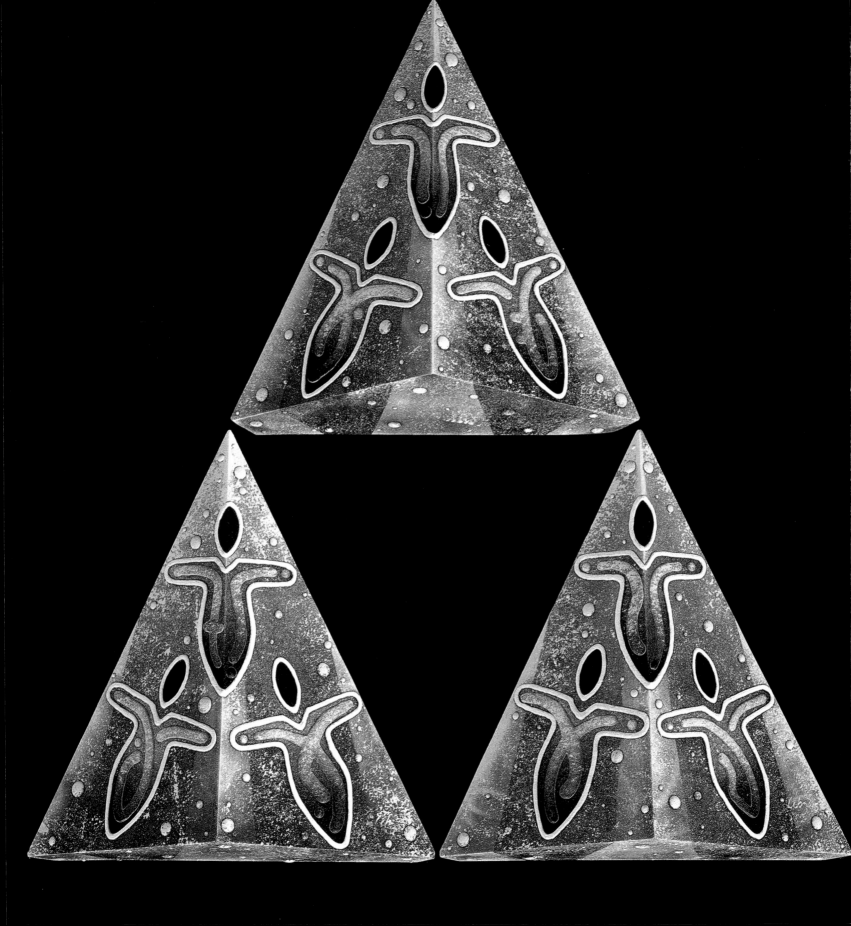

"Our Andy Lakey angel painting helps us live with the tragic loss of our daughter and rejoice that we have our own angel in heaven…. How do you thank someone for an angel?"

JEANNE PAYNE

COLLECTOR

MURRIETA, CALIFORNIA

1995

Angels #1198, 1199, 1201, *each measuring 19" x 18" x 19", wall sculpture, acrylic on wood, 1995.*

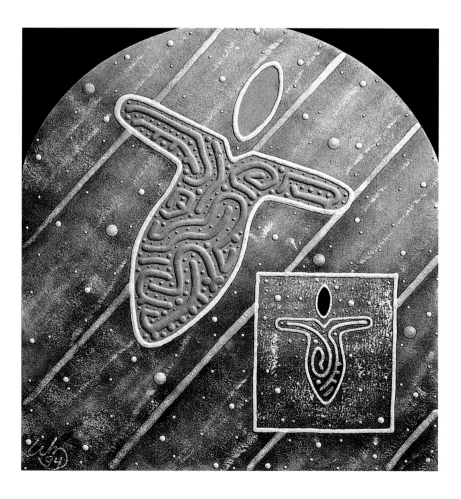

Angel #962, *39" dome, acrylic on wood, 1994. Collection of the artist.*

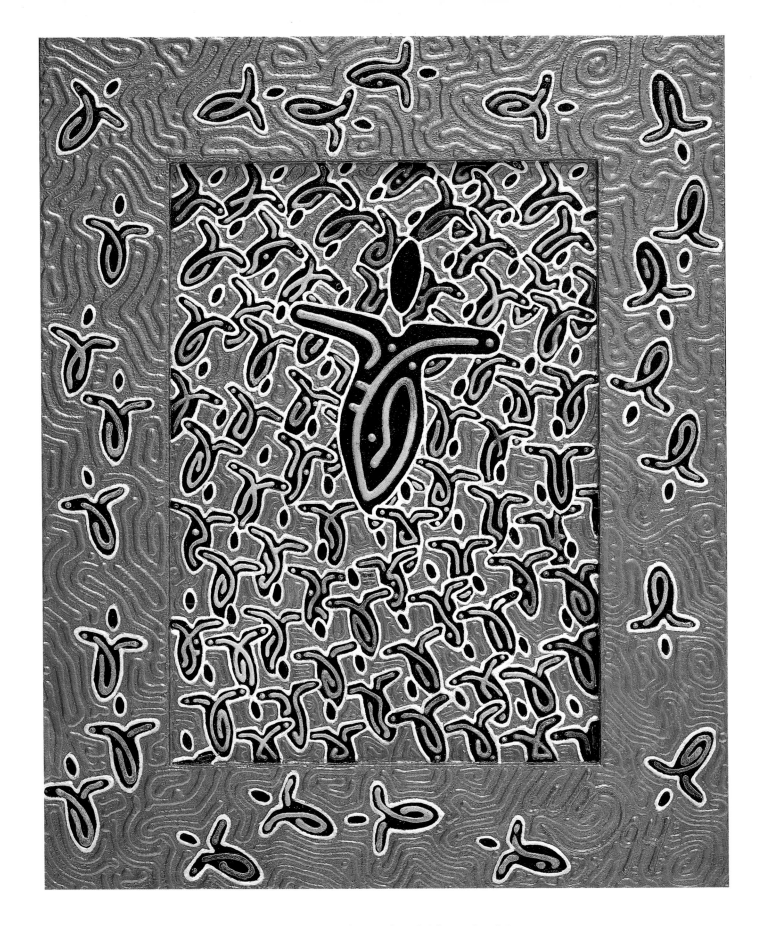

Angel #1001, 16″ x 20″, *acrylic on wood, 1994. Collection of Basuki Purnomo.*

Although his work had garnered national television exposure and captured the attention of many well-known people, it was always described as "art for the blind." Lakey often described it that way himself, and he concentrated on developing his textured lines rather than on the imaginative use of color. To some extent, this reflected his fascination with the deep blackness that he had witnessed during his near-death experience, as well as his deeply felt belief that he was keeping his promise to God by giving something back with this new art form. However, it also reflected his natural talents. Pierrette Van Cleve put it succinctly: "I wouldn't say he has a natural affinity toward color; he has a natural affinity toward line." ¶ Nonetheless, in a relatively short time Lakey developed a striking sense of color. When he met Chantal in November 1991, he had been painting for less than two years and had already created an impressive body of work. It would be an oversimplification to call these early paintings colorless, but the colors were muted—almost monochromatic—always secondary to the textured lines and shapes that rose from the canvas. Now, as if a new fountain of inspiration had opened within him, Lakey began to overlay his textures with beautiful pastels, so that the paintings exploded for the sense of sight as well as the sense of touch. With the pastel period, Andy Lakey's angels became art for everyone. ¶ When Chantal became pregnant with Joy, Lakey's art entered yet another phase. Transported by the prospect of fatherhood, he talked to his daughter in the womb, connecting with her long before she was born. To Andy, the baby-to-be was like a little angel coming to them straight from heaven. Suddenly, gold became the dominant color of his work: golden angels, gold-framed mirrors, golden foil. On the day that Joy was born—January 6, 1993, the Feast of the Epiphany—Andy Lakey completed one of his most dazzling paintings and dedicated it to his first daughter. ¶ The difficult, yet equally joyous birth of Cora on August 5, 1994, marked another development in Lakey's art. "Cora is the iridescence," Chantal explains. "When she was born, Andy had another emergence. He was so happy that she was alive that he became very iridescent—iridescent purples, blues, and greens—just a whole different phase." Chantal Lakey, who has watched her husband's rapid development of color more closely than anyone, believes that Andy is now evolving further by working with the three color stages together—integrating the pastels, the gold, and the iridescence into one seamless whole. ¶ As he developed his sense of color, Lakey made a key shift in the physical foundations of his paintings. Ever since *My Seven Angels,* he had painted primarily on canvas stretched over wood, the format he had first encountered in the works of Paul

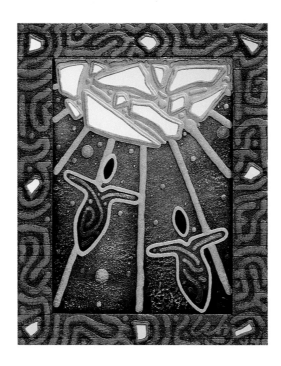

Angel #909, *21" x 27", mixed media on wood, 1994.*

Maxwell. There were exceptions—many of his early angel paintings were created directly on masonite boards, while his round paintings were done on precut plywood, but the wood he used was straight off the shelves of the home improvement store; he was a painter, not a carpenter. Then one day Lakey agreed to place one of his paintings in a "consignment mall," even though it didn't make much sense to him from a business point of view. "I really wasn't very interested," he remembers, "but I decided to go ahead and do it anyway." Just as he had "decided" to buy a couch when he didn't need one, as he had "decided" to go to an expensive restaurant when he wasn't looking for dinner, as he had "decided" to hang his paintings in a bank. ¶ "When I brought the painting into the mall, I noticed this beautifully crafted wooden train. I contacted the guy who made it, Russ Nelson, and he started making little wooden forms for me that I couldn't stretch canvas over, because they were indented with built-in frames. So I painted directly on the wood. It was specially-treated, kiln-dried, and the paint actually held. It went on smoother, more solid, tighter. It's intense; the wood actually absorbs the paint. It goes right into the crevices of the wood . . . the wood becomes the painting." ¶ Today, Russ Nelson still makes all of Lakey's wooden forms, offering the

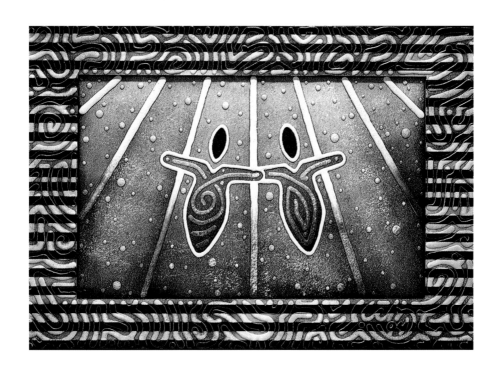

Angel #957, 36" x 26", acrylic on wood, 1994.

visionary artist a new realm of possibilities. "Whatever I can imagine," Lakey says, "Russ can build for me." ¶ Along with his artistic emergence, Lakey experienced a different sort of emergence after his marriage. On one level, it was a professional emergence, as his career took off to new heights of fame and financial success. Yet on another, deeper level, it was an emergence of truth. For the first time since he was saved by seven angels in the shower, Andy Lakey publicly revealed the story behind his art. ¶ It began with a move to Murrieta, a small but growing town on the road between San Diego and Riverside. "I had to move to a small town to become famous," he says with a touch of irony. Actually, he moved to Murrieta because Chantal found a teaching job there, and they were able to live together on a daily basis. Andy quickly became a small-town hero, creating two 4′ x 8′ paintings for the local hospital—the largest paintings he had completed up to that time. He organized individual doctors and local businesses to underwrite the project, and he dedicated the first painting at a gala event featuring Murrieta's "other" famous resident, actor Jack Klugman. At the dedication ceremony in February 1993, Lakey held the hand of an almost-blind, ninety-eight-year-old woman, and gently brushed her fingers across the canvas, eliciting a bright

Energy Panels, *11" x 32",*
acrylic on wood, 1992.
Collection of Dr. Don Myren.

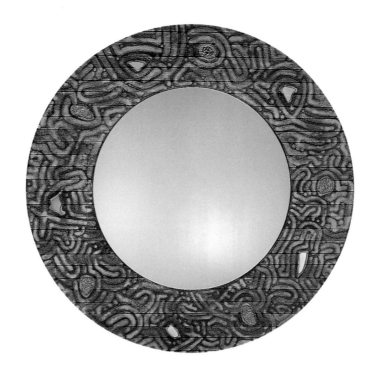

Nine Inches from the Bright Planet, *38" round, mixed media on wood, 1994.*

smile. "That's what my work is all about," he declared. ¶ That *is* what his work was about—the creation of healing art that could be touched as well as seen—but it was about something else as well. It was about capturing the other dimension he had experienced; it was about showing the world the angels who had saved his life. Yet when he moved to Murrieta, no one except Chantal and Domonic Mongello knew about this experience. Then, in September 1992, just as the Lakeys were settling into their new house, a local art dealer brought Andy a newspaper article about Eileen Freeman, who was receiving national press coverage of her AngelWatch Network and *AngelWatch Journal,* aimed at coordinating information about angel-related activities all over the world. ¶ Despite his sales background, Lakey seldom made a conscious effort to promote his art. Projects and connections came to him naturally, as if they were all part of his destiny, part of his mission. When he saw the newspaper story, he felt that Eileen Freeman was somehow part of his destiny, too, but he had to take the first step. Eileen Freeman remembers Lakey's call with striking clarity: "'My name is Andy Lakey,' the pleasant voice began. 'I'm an artist and I paint angels. I saw this story in our paper, and I knew I had to call you.' And it was the oddest thing—the moment he said that, I knew,

too, that he was supposed to call me. Without knowing a thing about him—in fact, I had never even heard of him—I was certain that God had meant for our paths to cross. Andy and I were destined to work together to help raise people's awareness not just of angels, but of the loving Creator who sends them into our lives to help us grow in light and wisdom." ¶ Lakey tried to describe his art to Freeman over the phone, but it was difficult to describe an art form that needed to be seen and touched. So he sent her a small painting, and the instant she saw it, Eileen Freeman knew that Andy Lakey was a man who had seen angels. She had seen angels, too—heard them speak, felt their loving presence—and she immediately recognized the angelic energy that Lakey expressed in his art. As they continued to develop their friendship in a series of phone calls, Andy gradually revealed bits and pieces of his angel experiences. By that time, Freeman was writing her first book, *Touched by Angels,* and she asked the artist if she could include his story in the book. ¶ "Andy agreed," Freeman recalls, "although I felt a reluctance in his answer. I could see that he was being pulled two ways in his mind. One direction urged him to share everything openly and fully. The other direction kept whispering, Keep it a secret. No one will understand." ¶ As Andy Lakey wrestled with the issue of revealing his past, Freeman discovered that another Lakey also had an angelic experience. One day, when the author called to talk with Andy, Chantal answered the phone, and their pleasant small talk quickly evolved into the story of Chantal's dramatic rescue by angels on a cliff in Oregon. Nearing her deadline on the book, Freeman had a limited number of chapters devoted to personal stories; another story had just dropped out, and she had room to include Chantal's experience, which she described fully and beautifully. ¶ Andy's story was a different matter. Just before Freeman was about to submit her manuscript, the artist decided that he did not want to share the details of his near-death experience, particularly the self-destructive lifestyle that preceded it. Nor did he want to discuss the vision of three angels in the ball of light, the vision that gave him his mission and his artistic

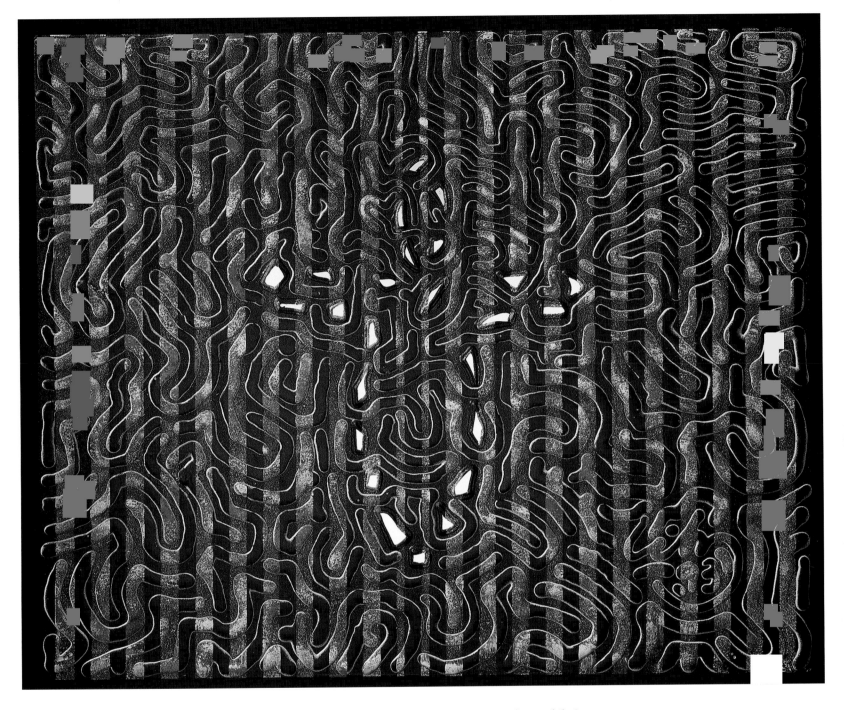

Angel #680, *36" x 30", mixed media on wood, 1993. Collection of Jerry and Sho Simon.*

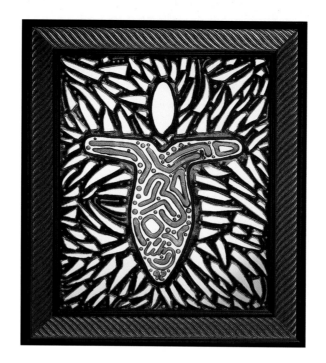

Angel #295, *24" x 29", mixed media on wood, 1992. Collection of the artist.*

Angel #682, *36" x 48", acrylic on canvas over wood, 1993. Collection of Jerry and Sho Simon.*

technique. It was a shared decision, really, between Andy and Chantal. Andy had never been comfortable discussing these experiences, and except for Domonic and Chantal, he had kept them to himself for years. Chantal was carrying their first child, and it was only natural for an expectant mother to be protective of her child's future. Did they really want their little girl to grow up and discover that her father had been a drug abuser? ¶ Lakey assumed that Freeman would want to pull the story from the book, but she surprised him. "I truly believe God wants your story—in whatever way you want to share it—to be in my book," she told him. "I'll write around your life before you saw the angels and focus on how your life changed as a result. But I want your story." ¶ Freeman did exactly as she promised, although she had to convince her editor that the story was powerful enough to include without a clear description of the artist's near-death experience. In the end the editor agreed, and the publisher even used Lakey's first angel painting, *My Seven Angels,* as the endpapers of the book. *Touched by Angels* was published in the fall of 1993 and marked a major turning point in the lives of Andy and Chantal Lakey. They were barraged by offers to appear on talk shows, and Andy's story was included in the NBC documentary, *Angels, the Mysterious Messengers,* hosted by Patty Duke, while Chantal's experience was featured in a special on CBS. For Andy, other television features followed, including CNN, *Lifestyles,* and *Sightings.* Liguori Press, a Catholic publisher, produced a

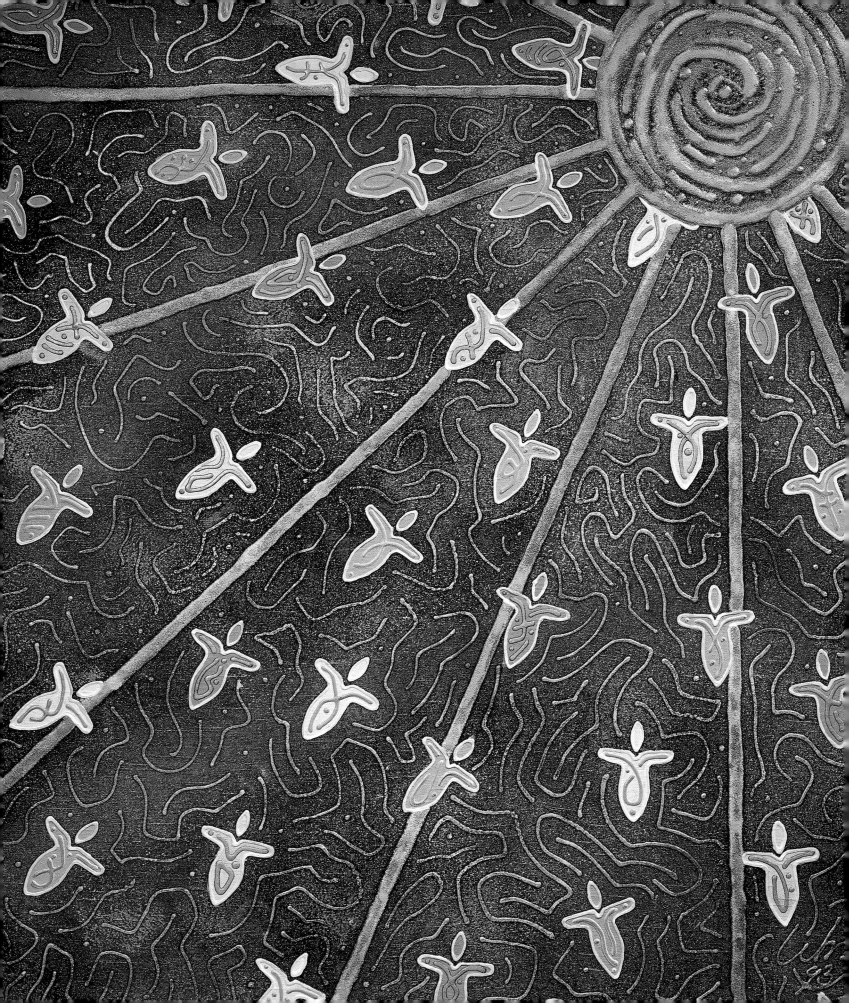

video on his life and work, which they distributed to the religious market, and he was profiled in publications ranging from the *Washington Post* to the *National Enquirer*. ¶ Whereas Freeman's book danced gently around the thorny issues of Lakey's past, subsequent media coverage revealed the self-destruction in all its embarrassing details, with some shows even dramatizing his cocaine overdose and angelic intervention. Revealing the whole story had been a difficult decision for Lakey, but in the time between the publication of *Touched by Angels* and his first talk-show appearances, something happened that changed his mind. ¶ During the early morning hours of Halloween 1993, actor River Phoenix stumbled out of a Hollywood hot spot called the Viper Room and died on the sidewalk, the victim of an apparent valium and cocaine overdose. The tragic, unnecessary death of the talented young actor struck a powerful chord in Andy Lakey. Ever since his own drug overdose, he had struggled with the question of full disclosure. On the one hand, it was not an experience he was proud of, not something he wanted to trumpet from the rooftops. And he respected Chantal's concern for their daughter Joy, now a bright, rambunctious ten-month-old, just beginning to take her first steps. ¶ On the other hand, the more attention his work received, the more difficult it became to avoid discussing the experiences that formed the foundations of his art. It almost seemed as if he was doing a disservice to the angels by not coming right out and telling the world of the healing grace and inspiration that they had given him. And perhaps by telling his story, he might help other young people to avoid the sad fate of River Phoenix. "You never know how your life will touch others" Lakey reasoned. ¶ This time, Chantal agreed. Joy would understand that her father had taken a wrong turn on the path, but she would also understand that he had found the right road in the end. Andy publicly revealed the story behind his paintings for the first time on the *Oprah Winfrey Show*. He's never looked back since, never questioned his decision to go public. "It's always better to tell the truth, but I had to wait for the right time. If I had told the story when I first started painting, people might have thought it was something I made up to get attention. I didn't want that. I wanted the paintings to be judged on their own merits. By the time I told the story to Oprah, I'd already achieved recognition as an artist. I felt it was important to get the anti-drug message out and to give credit to God and the angels for saving my life and giving me the power to paint." ¶ During 1994, Andy Lakey's public image went through a dramatic transformation. Not only was he a unique artist who painted for the blind, he was an artist who painted angels because he had

been saved and inspired by them himself. Lakey began to travel around the country, speaking to groups of interested listeners about his life and his experiences. His first public speech, at a church in Birmingham, Alabama, was a small revelation: "Rev. Gerald Bartholow invited me to speak at his church, where he was having a conference on angels. I agreed to do it—I just felt it was important—even though I had absolutely no idea why I was going there. I had no dealers in that part of the country, no art to sell, nothing except me and my story. I had never spoken before a large group of people before, and I was so nervous I could barely open my mouth. But I went up there and began to talk, without notes, just telling my story. I spoke for an hour, and when it was over they gave me a standing ovation." ¶ It was one thing to tell his story briefly on the *Oprah Winfrey Show*, with the talk-show host guiding him through the paces while hot lights and cameras provided a strange sense of unreality. It was something else to stand in front of a group of quiet listeners in a church, in a corner of the country he'd never visited before, telling his story straight from the heart. That night in Alabama, Lakey discovered just how forgiving and loving the American people can be. The self-destruction of the artist's early life was only a prelude . . . the song was Andy Lakey's redemption and the power of his art. ¶

Angel #501, 38″ round, mixed media on wood, 1993. Collection of Joy and Hugh Bancroft.

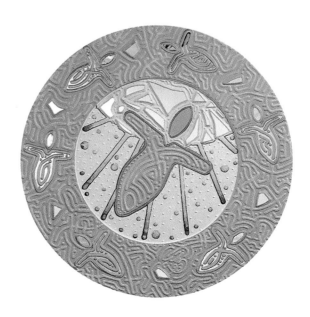

Overleaf: Detail from Angel #888, *48″ x 36″, acrylic on wood, 1994. Collection of the artist.*

EARTHLY ANGEL

Planet Bathing, *36″ x 48″, acrylic on canvas over wood, 1990. Collection of President Jimmy Carter.*

ANGELS IN LIFE AND DEATH

by Chantal Lakey

Long before she met Andy Lakey, Chantal Lakey had an encounter with angels who saved her life, an experience just as dramatic and powerful as the experience of her future husband. Here's her story.

Dale and I had a wonderful relationship, not as deep a spiritual connection as Andy and I have today, perhaps, but full of fun and adventure. We just enjoyed being together, going places, doing things, and we planned to marry and share that sense of fun and exploration for the rest of our lives. Apparently, God had other plans.

In January 1978, we went on a ski trip in the Sierra Nevada. Neither of us had ever skied before, and I stuck to the beginner slopes, but Dale attacked the expert runs after a single day of lessons. He was a natural athlete, just the opposite of me. After skiing, we continued north to visit Dale's cousin in Eugene, Oregon. Then, on the way home, we were driving along the ruggedly beautiful Oregon coast when we passed a sign that read *Lookout Point.* "There's a great hike to the top of this mountain," Dale told me. "I've been up there, but no one's ever climbed with me. Do you want to try it?"

"Sure," I said. "Sounds like fun." I hadn't done much hiking, but I was always willing to experience something new, and Dale's athletic ability gave me confidence. We followed a winding deer trail to the top of the mountain. It wasn't an easy climb, but the view was worth it—360 degrees of stunning scenery, with the wild ocean crashing below and an emerald green forest stretching toward the east. It was very romantic. We held each other close on the top of the world, or at least the top of our world.

When it was time to go back to the car, Dale noticed another trail heading down toward the beach. "This looks like it leads to a different way down," he said. "You want to try it?" I just smiled and followed his lead. At first it seemed like a great adventure, but suddenly we realized we were in trouble. Over five hundred feet above the beach, the trail just disappeared into a sheer cliff of loose shale. By that time, a fine rain had begun to fall, making the treacherous surface even slicker and softer. We tried to go back up the way we had come, but the shale crumbled wherever we grabbed or stepped. It seemed like the only direction to go was down.

Dale bravely maintained his confidence, although we both knew we were in serious danger. "How's your fear factor?" he asked. "Do you think we can make it?"

"Let's try," I replied. What else could I say?

Dale led the way, cautiously working his way down, stepping from one small rocky ledge to another, then helping me to follow, with every move I made showering him with loose rocks, mud, and shale. We were still almost five hundred feet above the beach when Dale stepped onto a tiny outcropping that broke away beneath his weight. He reached back toward me, and for a brief moment, his eyes locked with mine. He didn't say a word. He knew it was over. Then he fell—smashing his head on a ledge . . . falling . . . falling . . . until I couldn't see him anymore.

"Dale!" I screamed. "Dale! Help! Help!" There was no answer. Dale was gone, and I was all alone on the cliff. More alone than I had ever been before.

Instinctively, I tried to find a way down, not only to save my own life, but in the desperate hope that Dale was still alive, down on the beach, needing me. It was useless. Every time I moved, the wet shale crumbled away. Overwhelmed with fear and horror,

I cried out, "Dear God, please help me!" I wasn't very religious in those days, and I hadn't prayed in a long time, but the words came without thinking.

Instantly I felt a strange, soothing presence like angels in a mist that came to help me. I heard strange celestial sounds, almost music, but not music; maybe the echo of music. Then I began to find my way down the cliff. I had to make all the moves myself, and I was living with terror all the way, but before I knew it, without understanding how it happened, I had descended almost four hundred feet down the sheer, rain-soaked face of the cliff.

Now I was about one hundred feet above the beach. I'd come so far, but there was still a long way to go. Suddenly, I lost my footing and began to slip wildly down the cliff. "Oh no, God, not now!" I cried. At that moment, some awesome force swooped me up like an invisible hand and set me firmly back against the rocks. From there I made it down the rest of the way to the beach, though I don't remember how I got there.

Dale's beautiful, athletic body lay on the rocks, a broken, lifeless shell. It was horrible in the deepest sense of the word, yet as I gazed upon him, the echo of music grew louder, and I could sense the presence of angels, helping him in death just as they had helped me in life. For the first time since the whole ordeal began, I felt a strange sense of peace. I knelt down and kissed Dale gently on the lips. Then I unfastened the golden necklace he wore around his neck—a perfect match to my own necklace, a symbol of our love.

Numb and shivering in the cold rain, I found a narrow, twisting deer path that led up from the beach, through thick brush, and finally back to the road. A passing motorist took me to the sheriff's office, where they organized a professional rescue party to retrieve Dale's body. But when the rescuers arrived at the top of the cliff—with all their ropes and hooks and special climbing equipment—they realized there was simply no way down. The next morning, they called a helicopter in to land directly on the beach.

Later, one of the rescue team told me, "You're a living, breathing miracle, Chantal. How you got down that rock face safely is beyond me." I didn't tell him that the power that rescued me was beyond us all. I didn't tell anyone about the experience, in fact, until I married Andy almost thirteen years later. Yet ever since that day in Oregon, I have felt the presence of my angels. They have never left me. I feel a real sense of security, and I'm not afraid of dying. I know the angels are there for us in life and in death.

EYES OF THE SPIRIT

An Interview with Eileen Elias Freeman

Eileen Elias Freeman is the founder and director of the Angel-Watch Foundation, a nonprofit organization whose motto is: "Searching for God through the work of the angels." She publishes the bimonthly AngelWatch Journal *and sponsors the annual Earth Angel Award, which recognizes an individual who works behind the scenes to make the world a better place. Since her best-selling first book,* Touched by Angels, *Freeman has written four other inspirational works, including* The Angels' Little Instruction Book. *Eileen Freeman has a B.A. in the History of Religion from Barnard College, and an M.A. in Theology from the University of Notre Dame.*

When Eileen Freeman first spoke with Andy Lakey, the artist promised to send her a small painting in the mail. Intrigued by the way he had described his art yet unable to fully picture it in her mind, she found herself checking the mail each day with curiosity and interest. Then one day, a little padded envelope arrived, and Freeman saw a Lakey angel for the first time, an epiphany that she later described with heartfelt eloquence:

"The minute I opened Andy's package and looked at the small artwork carefully cradled inside, I knew this was a man who had seen angels. I had seen them too, beginning when I was a child, and the similarity was unmistakable. I don't mean the appearance, but the spiritual energy contained within. I held the canvas in my hand, seeing first the bold image in the center. It was an angel unlike any I had ever seen—featureless, almost without form, barely recognizable as an angel. But I felt the energy, the spiritual dimension . . . and I understood instinctively what Andy was trying to convey.

"I looked curiously at the painting, wondering where the energy was coming from. I began to notice how the angel was balanced, oriented toward the four corners of the globe, its inner force straining to reach out in all directions. I felt a strength of spirit, a power within, as if the angel were trying to escape from the canvas to be about God's business of loving, of healing, of cherishing. The geometric lines filling and surrounding the angel were all moving away from me off the canvas like lightning. I had the feeling that if I let go of the painting, it would take off and fly.

"Then, as I looked more closely, the image began to move before my eyes. The thick black lines laid on a mauve background (how had he known those were the colors of *Angel-Watch?*) were no longer static. Overlaying the lines was a wash of subtle multicolor rainbows that glittered in the sunlight and struck sparks from the canvas in some artistic alchemy I could not fathom. The angel was filled with light, and I could feel that light moving my heart to joy. I had seen that light before—long before, the night my guardian angel came to my bedside. . . . It was good to see it again.

"I reached out automatically to try to touch one of the sparks, and I felt with my own fingers what Andy had briefly explained to me—that his work was multidimensional. My fingers traced the soft contours of the paint, laid on so thick. I closed my eyes, the better to feel it, and felt myself drawn into a subtle maze. The angel was leading me deep within my own heart as I explored its depths. . . .

"I was drawn into prayer as I opened my eyes again. Through the deceptively simple painting, I felt I had touched

the heart of an angel. Standing before the canvas was like looking into heaven. I said to myself, *If Andy Lakey ever has a vision of God—world, look out!*"

Later, Eileen Freeman acquired another Lakey painting, one of his largest, a 5′ x 4′ creation with dozens of angels soaring through the planets toward a mirrored sun. Freeman terms the painting, "awe-inspiring," and she recalls a small, yet telling moment that occurred when she hired an electrician to install a spotlight in her living room ceiling to shine on the painting. "I went into my office for some time to make a phone call, and when I returned, I found him standing motionless before the canvas, with a cordless drill in his hand, staring intently at the painting. 'It really does move,' he murmured, half to himself."

As director of the AngelWatch Foundation, Eileen Freeman has heard "over a thousand" stories of angelic intervention. She has studied historical accounts of angels in the world's great religions, and—perhaps most importantly of all—she has experienced angels directly, beginning when she was a child and her guardian angel appeared to comfort her after the death of her grandmother. Much later, as a college student, Freeman felt an invisible hand on her shoulder and heard a disembodied voice—a voice she recognized as her guardian angel—telling her not to go into an apartment building, where another young woman was murdered in the elevator a few moments later. She has had other angelic contacts as well, and each experience has been different, she explains, "because I was different."

Although the angelic form that Andy Lakey saw during his near-death experience has become the defining icon of his work, Freeman believes that angels have no form. "Angels are spirit," she says simply, "so any form that we see is one that they have adopted deliberately in order to help us to see something, either a form that they know we recognize as an angel or a form we can accept.

"Andy saw angels insofar as one can see angels . . . but when you're in that state between this world and the next, it's kind of a moot point whether you're seeing with the eyes of your spirit or the eyes of your body. The fact is that Andy was probably seeing with the eyes of his spirit, but the only way to

describe what you see is to use terms that pertain to this reality, the physical world. They're simply not applicable to describe something that's not material in the first place. So one gropes and one tries."

After his second angelic experience, Lakey described the beings who came to him in the ball of light as "three men with beards," a radically different appearance than the featureless forms he saw during his near-death experience. Yet, Freeman reasons, both forms were simply representations that the formless angels had taken on to help Andy at two radically different times in his life. And she emphasizes that angels do not come from somewhere else to help us; they are here with us all the time. "Heaven is right here, coterminous with what we see, but because it's not a part of earth, we don't see it. Our senses are geared to perceive only the reality of the world."

When angels appear, she explains, "it's simply a strengthening of the bond between us. . . . Angels are not a miraculous thing; angels are part of the natural order. But because their beings are made of spirit and not of flesh, they're something we can't see. We don't think of the wind or the air as something miraculous even though we can't see it. We can measure it quantitatively; we can't do that with angels. Angels are simply life forms."

Despite her definite, carefully-reasoned opinions about angels, Freeman is not primarily concerned with the phenomenology of religious experience. What matters, she believes, is the way that divine intervention transforms a human life. And in the case of Andy Lakey, the transformation was dramatic. "Andy was a drug abuser whose only purpose in life was to seek his own pleasure," she says frankly. "After this experience Andy was free of drugs. He was eager to give back to God; he was searching for who God was, what God meant to him. He made a commitment to God and to others. That I see as one of the main hallmarks of religious experience, that we become outward-centered, not selfish and ego-centered. . . . I look at Andy and I see a man who is dedicated to making this world a better place, to share the awareness of God that he received in his life-transforming experience. And I think that's wonderful."

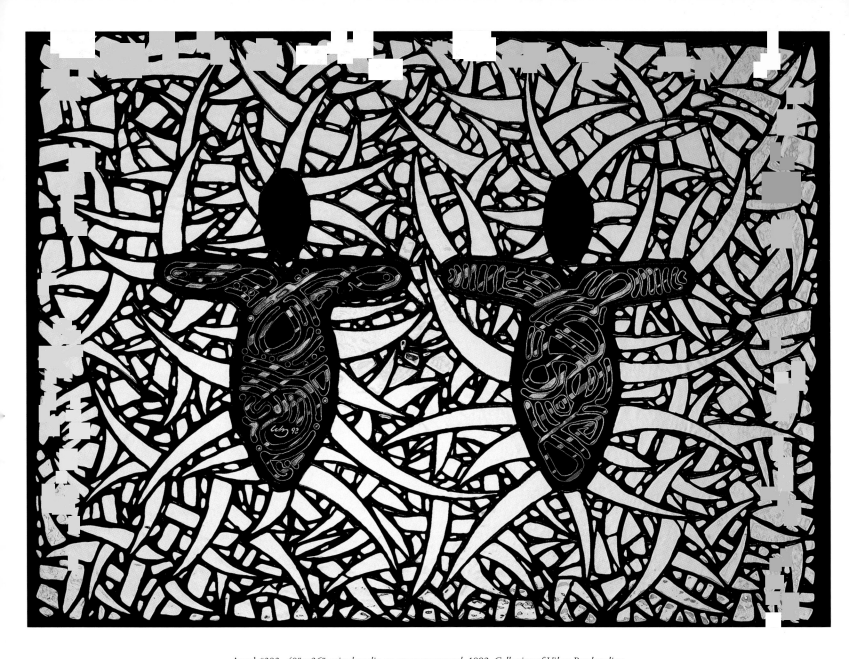

Angel #393, 48″ x 36″, mixed media on canvas over wood, 1992. Collection of Viken Berghoudian.

All art represents experience—real or imagined, physical or spiritual—but for Andy Lakey, the idea of representing his experience took on a unique focus. Every Lakey painting, every sketch, every artistic creation, is an attempt to represent a single life-altering experience. The relationship with the Angel 2000 series is clear, but his celestial abstracts and space creatures, with hidden angels and countless poles of light, also followed directly from his vision of the other dimension. Even his framed mirrors and more recent paintings of animals for children contain the raised shapes and lines and interplay of light that characterized his near-death experience. Considering the intensity of his focus—and the intensity of his original experience—it's not surprising that Lakey hoped to move beyond mere representation and actually capture the experience itself. He not only wanted to show others what he had seen, he wanted them to know the angelic energy that had transformed his life. And from the very beginning, he believed that he was succeeding. "I always felt there was something magical about the paintings," he says, "as if some of the light surrounded them." In the early years—before he revealed the near-death experience that inspired his work—Lakey occasionally heard reports from those who found his paintings soothing to body, mind, and spirit. When he asked his well-known collectors for quotes to be used at a fund-raiser, they responded in language that reflected this deeper, spiritual dimension. Gloria Estefan wrote, "Every time I look at the angel by Andy Lakey, I think inspirational thoughts;" Chuck Yeager offered that Lakey's painting "excites one's imagination." Yet despite such glowing praise, the real spiritual power of Lakey's work was only beginning to develop. In late 1992, Jerry Simon, a retired engineer and successful businessman, wandered into the artist's Murrieta studio, where he was working on the two large paintings for Sharp Hospital. Impressed by Lakey's dedication to healing through his art,

CHAPTER SIX

Art of Energy

Simon bought a painting for himself and his wife, Sho. They liked it so much that they bought another . . . and another . . . and another. Finally, the Simons sold their entire art collection—which included an original sketch by Picasso and works by Andy Warhol—so that they could buy more of Lakey's creations. Today, they own over fifty original paintings, filling their spacious home with Lakey art. When asked why he made such a commitment to a single artist, Jerry Simon finds it difficult to convey his feelings in words. "It's sort of a spiritual thing," he says quietly. "The paintings changed our lives. We've been healthier and happier." ¶ Jerry Simon discovered Lakey's art through personal contact with the artist, but others had equally powerful experiences directly from the art itself, with little or no knowledge of Lakey's life or the story behind his work. Marie—an operating room nurse from San Diego—first glimpsed a Lakey angel at an exhibition in July 1993 and was immediately drawn to the sense of light around the custom-crafted, silver-painted frame inscribed with Lakey's three-dimensional lines and shapes. "The voice within me knew I had to have the painting," she recalls, and when the gallery owner invited her to touch the angel, she reached out with her right hand and felt an intense, hot vibration. "I brought the angel home," Marie writes today, "and my life and health changed directions for the better." ¶ When she first saw Andy's angel, Marie was going through a difficult period—recently divorced, trying to raise her daughter as a single mother while recovering from the physical and emotional effects of a car accident. Despite her own medical background, Marie had to battle through a legal and medical minefield in order to get the treatment she felt she needed, and along with her

Pole of Light, *9″ x 84″, mixed media on wood, 1991. Collection of Jerry and Sho Simon.*

physical pain, she carried an oppressive load of anger. Andy's angel painting helped her through the crisis and set her on the road to healing: "I believe the healing energies in Andy's paintings relieve my physical pain for periods of time. The primary benefit was that the Lakey angel helped with releasing the anger that had become part of my life as a result of the medical, legal, and personal denial of family and friends. Through energy field work and prayer, I was able to get to the emotional root of my problems—what I call the 'internal code of silence'—and begin the healing process. Andy has made himself available to me whenever requested. He truly is a healer and a gifted energy artist." ¶ While Marie's life was changed by a Lakey painting she first saw on the wall, Teri Martin was transformed and inspired by simply glimpsing Lakey's *My Seven Angels* in Eileen Freeman's book. A postal worker in the Seattle area, Martin had been lost in a deep state of depression for over four years—a time when she felt she was "being led toward a dark hole by dark spirits"—and had recently attempted suicide. Despite counseling, she continued to feel empty and hopeless. Then one day she happened to see Eileen Freeman interviewed on television and felt compelled to buy her book immediately, though it was not the type of book she would normally purchase. "As I opened the book, I saw Andy's *My Seven Angels* on the inside cover, front and back. Just seeing the angels sent a shiver down my spine, and then my body felt filled with wonder and reverence." ¶ Martin later obtained several works of Lakey's art, including a small painting from the Angel 2000 series. Although she continues to have difficult days, she believes that she has turned the corner, stepping out of the darkness toward a better, more meaningful life in the

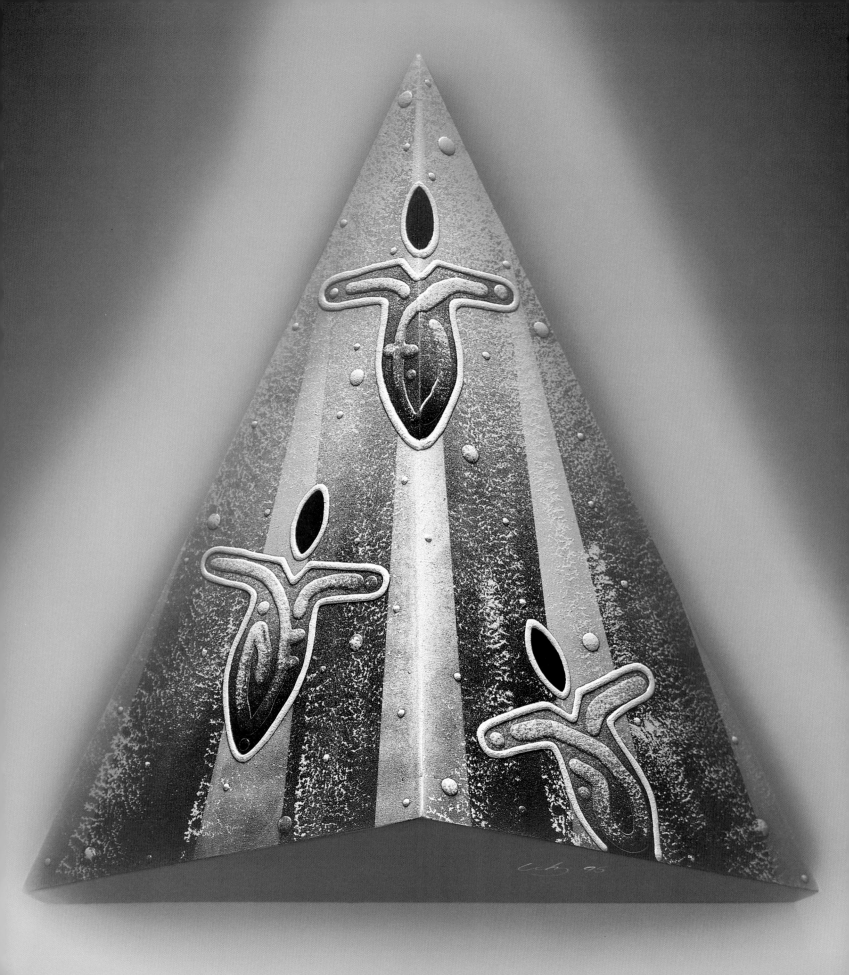

"Never in my life have I seen one artist's work impact so many people."

PETER DAVIS
OWNER OF ANGEL GALLERY
PORTLAND, OREGON
1995

Angel #302, 34" round,
acrylic on wood, 1990.
Collection of General Chuck Yeager.

Angel #1050, *52" pyramid,*
wall sculpture—acrylic on wood, 1995.
Collection of Peter and Karen Davis.

grace of a loving God. And she credits Andy's angels for the change: "Somehow these are my angels, too—they are a gift from God, given through Andy. They were shown to me by Him as a means of setting my life on a new course. My counselor likens the change in me to one who has had a near-death experience. I don't know if I agree with that comparison or not. What I *do* know is that my life is changing all the time, and I now feel I'm being led by "light spirits"—being led by God and his angels, and it all began the day I first saw *My Seven Angels.*" ¶ Around the same time that Teri Martin discovered Andy's angels in Washington, a similar discovery occurred in Portland, Oregon, where Peter Davis and his wife, Karen, had recently opened an angel store and art gallery in an exquisitely restored Victorian house. One day an elderly gentleman in a wheelchair came into the store, accompanied by two of his sons and his wife, who later told Andy Lakey the story, sharing it on the condition that she and her husband remain anonymous. Originally from the east, they had come to Portland to visit their grandchildren because the grandfather was dying of cancer. While his wife bought some angel cards, the man in the wheelchair was drawn toward a set of steep, winding wooden steps that led upward from the main floor. ¶ "What's up there?" he asked. ¶ "It's an art gallery," Davis replied. ¶ "Oh, he wouldn't be interested in that," said the man's wife. "He hates art." ¶ Nonetheless, the dying man insisted on going upstairs to the gallery, so his sons helped him out of his wheelchair and up the winding stairs. As soon as he got to the top of the stairs, still supported by his sons, he was drawn toward a small, 5" x 7" Lakey angel. He took it off the wall, cradled in his hands, and insisted on going right back down the stairs to buy it, without even asking the price. His wife was dumbfounded. She had never seen her husband show the least interest in modern art, and now he was buying an original painting on what seemed like a whim. ¶ The man lived another year or so, and he carried the little painting with him every moment—when he went to the supermarket, when the nurses came to bathe him, when he went to bed at night—even making a pouch in which to hold it. It gave him so much comfort during his last days that his wife had the painting buried with him. ¶ During a formal showing at the Portland gallery, Virginia Robinson, whose niece Theresa had recently passed away after a long, heroic battle with AIDS, found herself overwhelmed with emotion, surrounded by so many images of angels. Seeing the woman crying in the middle of the room, Lakey embraced her, suggesting that she go and touch one of the paintings. "People have different responses," he said. "Some feel comfort." ¶ Walking to the side of the

room, Virginia ran her hand over a small painting. "I felt a hand on my shoulder," she recalls, "and heard a voice saying, softly but firmly, 'I understand, and everything will be all right. My name is Theresa.' When I turned around to see who had touched me, there was no one there." ⁋ That night, Virginia called her sister Sherrie, Theresa's mother, to deliver the message that she had received from the angelic voice. "We shared a very special moment," Sherrie explains today. "We reflected on Theresa's life, her love, her special courage, and the gifts that we still receive from her even after death. She's with everyone who needs a guardian angel, everyone who's suffering from AIDS. I'm proud to be the parent of an angel." ⁋ "Never in my life have I seen one artist's work impact so many people," Peter Davis says. "There's a specific painting for a specific person. There may be a dozen others that are similar, and some people will walk up and say, 'Gee, it's all the same.' But others will be drawn like a magnet to the painting that's right for them." Like the 5" x 7" angel that was just right for the dying man in a wheelchair. Like the painting that called up the touch and voice of Theresa. Like the angel in the silver frame that sent hot energy through Marie's hand. ⁋ In early 1994, after he revealed the full story behind his art on the *Oprah Winfrey Show,* the spiritual dimension of Andy's Lakey's work entered yet another phase. It began with a call from a woman in Arizona who had recently lost her daughter. She, too, prefers to remain anonymous, but it was her desperate search for solace that led the artist in a new direction: "She asked me to paint her daughter's angel, and I told her I couldn't do that. I can't paint someone's angel; I can't even paint my own angel. I don't have that kind of power. I explained to her that I had an experience, and that what I paint is what I saw in the experience, that I'm trying to capture that experience. But she was insistent. She called me again and again, and I would cry with her over the phone; it was very sad. Finally, she asked me if I would paint an angel in the presence of her daughter, that she would send me a photograph. I said, 'I don't see why not,' so she sent me the photo. ⁋ I had never done this before, but I felt guided to wrap the photo in a white cloth and tape it under the painting. It was a very spiritual experience for me. When I finished, the painting was different from anything I'd ever painted before. It had a lot of iridescent colors . . . sparkles . . . it just looked different, it lifted me to another level. When she saw it, the woman told me that she felt such peace from that painting; she felt her daughter was with her. That was my first healing painting." ⁋ The Arizona woman told her friends, one of them a new mother. She sent Lakey a photo of the baby, and he created a

painting based on the energy he felt. "That was just as powerful," he recalls. "Now I had done a painting for some-one who had passed away and for someone who had just been born. From there it grew like wildfire." ¶ Andy Lakey denies that he possesses psychic powers, and he makes no claims for his energy paintings other than to say, "Whatever energy comes through, I paint." Yet the energy paintings have brought a new level of excitement and dis-covery to his art, for the artist as well as his collectors. "I probably prefer doing these paintings more than anything else I do. Sometimes I'll tape objects under the canvas, and I'll forget who's underneath which painting. I work on fifteen or twenty paintings at a time—some energy paintings and some regular paintings—and I'll mix them all up in the work area of my studio. It's very interesting; I can always tell when I'm working on an energy painting. I'll feel special colors, a special flow of angels across the canvas." ¶ Lakey takes pains to avoid knowing too much about the people behind the canvas. When he created an energy painting for Betty Eadie, who has written an account of her own near-death experience, *Embraced by the Light,* he told her quite frankly that he hadn't read her book or listened to her tapes or even seen her interviewed on television. "I'll read the book after I do the painting," he said. "Right now, I just want to concentrate on your energy." Not surprisingly, Lakey found Eadie's energy compelling, complex, and intriguing, and he created one of his most unusual paintings in response. "I could have painted Betty's energy on the moon," he says, "and I still couldn't have captured it all." ¶ Several months before creating Eadie's painting, Lakey had a similar experience with the energy of an Ohio man named William Mitchell, a man whom he knew absolutely nothing about. ¶ "I received a Polaroid photo of Bill's hand, a Xerox of his hand, and a photo of him. I taped them under the panel and sketched a couple of angels, and it wanted to continue; I needed more space. I have a certain balance in my paintings. I can't just pile angels on top of each other. So I tried a little experiment. I work on an 8-foot by 8-foot board, and I took everything off the board and taped Bill's stuff under it as if it were the can-vas. Then I climbed on top of the board, got down on my knees and started sketching large angels until they filled the whole board—and it still wanted to go on. I couldn't fit his energy on an 8-foot by 8-foot board!" ¶ Lakey ended up capturing a part of Mitchell's energy on a smaller panel. It was only after the painting was finished that he discovered that William Mitchell has been a professional psychic for twenty years. ¶ Occasionally, the artist can't help but know the story behind the painting. That was the case when the family of Nicole Brown Simpson sent

Clockwise from top left: Angel #1364, Angel #1365, Angel #1367, Angel #1366, Each measures 6" x 8", acrylic on wood, 1995.

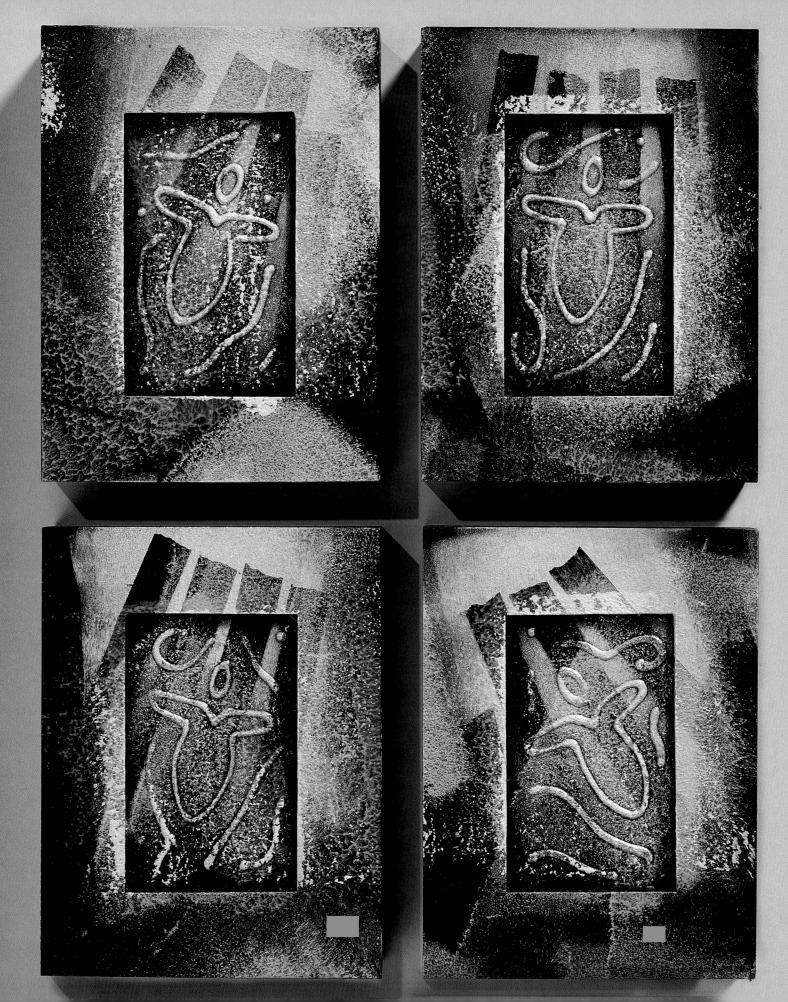

Angel #1319, 16" x 20", acrylic on wood, 1995. Collection of William Mitchell.

Lakey a photo of Nicole and her two children. The painting that he created—a stunning panel with twelve white angels outlined in gold, ascending toward the light—now hangs in the bedroom of Nicole's parents, Lou and Juditha Brown. They say that Andy's angels have provided them with a greater sense of peace and calm, helping them, in a small way at least, to better cope with their terrible tragedy. The painting will also be featured on a poster to publicize and raise funds for the Nicole Brown Simpson Charitable Foundation—the only time in Lakey's career that he has given permission for the use of one of his paintings on a poster. ¶ Although he creates many paintings for people who are happy and healthy, the healing nature of Lakey's work, along with the personal interest he takes in his collectors, often puts the artist in contact with those who are going through painful experiences. The most painful of all, he admits, are the grieving parents who have lost children. Although Lakey has no training as a counselor, he seems to have a natural ability to help these people through their difficult times, perhaps because he has experienced the fine line between life and death himself. "I'm like a pillow for their grief," he says. ¶ Three women in Ohio, who have all lost children, call Lakey their "familiar friend," though they did not meet him in person until long after connecting with him through his art and a series of personal phone calls. One of them, Bev Shank, later wrote to the artist, "Oddly enough, as each one of us spoke with you on the phone, we were left with a familiarity that cannot be explained. We all agree your voice was a very familiar voice, and each of us had the feeling that we knew you a long time ago somewhere." ¶ Bev Shank, Debbie Hefflinger, and their friend, Deb Franz, have all had

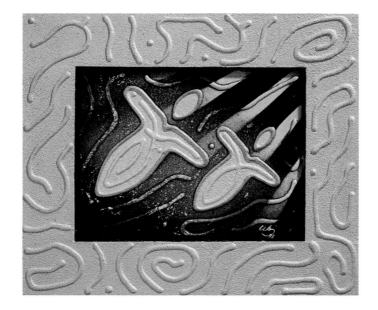

Angel #1320, *12″ x 10″, acrylic on wood, 1995.*
Collection of the Georgia Museum of Art.

Overleaf: Detail from Angel #1324,
28″ x 30″, acrylic on wood, 1995.
Collection of Lou and Juditha Brown.

unusual and comforting experiences with Lakey's art. The most remarkable occurred when the three of them went to a shopping mall. Hefflinger wore her custom-designed, miniature painting on which Lakey had created a rainbow above the angel, in memory of her daughter, Dana, who she believes once showed her a rainbow to heal her grief: "Towards the end of the day, Bev and I were standing outside a store just talking about our day of shopping. I noticed an older man walking toward us; he was maybe in his late seventies and dressed from head to toe in western clothes. His skin was very tan and weathered, and he was wearing a large, straw, western cowboy hat with lots of feathers. I can remember thinking he looked so out of place. He was moving very slowly right toward me and looking right at me. I just figured I must be in his way, so I started moving over a little. In a deep, gruff voice, he said, 'Wait. Don't move, don't move,' and kept walking towards me. I was never afraid of him; yet I don't know why. He walked straight up to me and just touched my Andy Lakey angel pin and smiled and said, 'Okay,' and then just walked away. I was so surprised at what he did. I couldn't speak and neither could Bev. Just then, Deb Franz walked up and we turned around to point out the older man to her, but he had vanished! There wasn't time to go to the next store, and he was moving so slowly we knew that he had just disappeared. I'm not sure what my 'angel in the mall' wanted me to know, but I do know I'll never forget him." ¶ Lakey's miniature paintings seem to have a strange power of their own, as if the angelic energy is concentrated into the tiny form. In the artist's hometown of Murrieta, a middle-aged man dying of cancer felt so much comfort from his miniature painting that he wore it

every moment until he died, much like the old man in the wheelchair who made a pouch in which to carry his painting wherever he went. But the Murrieta man derived more than comfort; he had visions as well—of angels and a heavenly city of God—as if the Lakey angel were a key to the kingdom that awaited him on the other side. ❡ Artist. Healer. Grief counselor. Caller of angels. Giver of visions. ❡ Art has always had the capacity to transport and transform the viewer, but the claims of Andy Lakey's collectors take us into uncharted territory. These stories are only the tip of the iceberg; Lakey has received thousands of letters, faxes, and phone calls over the last six years, and an impressive number of them report transforming experiences with his art. Lauren Rose wrote that, during a time of loneliness and despair, "I swear that little angel began to take on a life of it's own . . . trying to communicate something I needed to hear but couldn't," helping her overcome the depression and insecurity she felt as a result of early childhood sexual abuse. Cancer patient Jeanne Hays said that running her hand over a Lakey painting gave her more relief than all of her pain medication and chemotherapy. Angela Belfiore called to tell him that she got pregnant—following years of unsuccessful and expensive medical intervention—shortly after bringing a Lakey angel into her home. ❡ What's going on here? Is it possible that Lakey's paintings actually radiate healing energy and divine light? Or is it simply the power of suggestion? The artist believes it's a bit of both. He speaks of "the light"

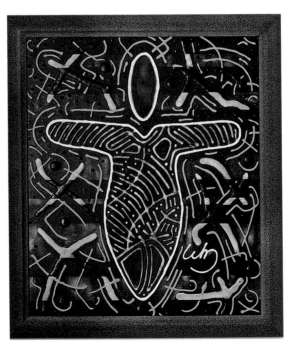

Angel #28, *18 1/2″ x 22″,*
acrylic on masonite, 1990.
Collection of Prince Albert of Monaco.

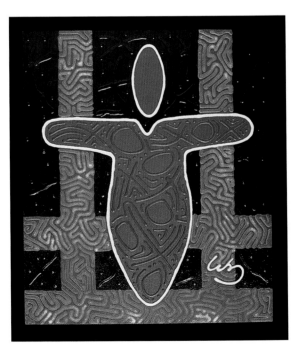

Angel #33, *18 1/2″ x 22″,*
acrylic on masonite, 1990.
Collection of Arnold Palmer.

"I did not set out to search for an Andy angel; instead the angel found me. There are no words to express the inner peace and miraculous awareness I feel—thanks to you, my familiar friend."

BEV SHANK
COLLECTOR
GRAND RAPIDS, OHIO
1995

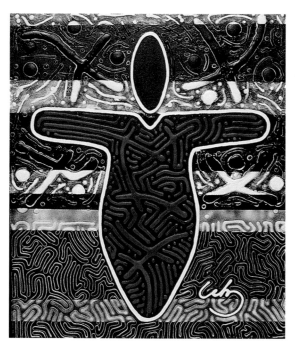

Angel #69, *18 1/2″ x 22″, acrylic on masonite, 1990. Collection of Ray Charles.*

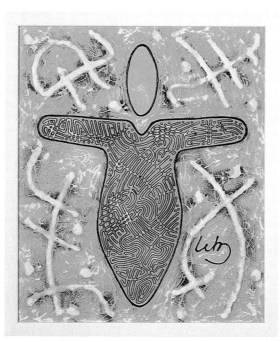

Angel #81, *18 1/2″ x 22″, acrylic on masonite, 1990. Collection of President Gerald and Betty Ford.*

surrounding his paintings, yet he would never claim that the art itself works wonders. "My paintings are a catalyst," he says. "I believe they help to release the spiritual energy that people already have within them." ¶ Betty Eadie, who gained insight into the nature of healing during her own near-death experience, offers a similar point of view: "In my experience, I was taught that sensory stimuli can trigger a healing response. Some people burn incense, and they feel a healing. In Andy's case, I believe that it's the actual colors and the organization and design of the angels—the energy of his particular art—that triggers the healing response in that individual." ¶ Lakey's paintings offer a soothing, healing quality to be sure, but is it possible that he has actually "captured" the celestial energy in his work in a literal as well as an artistic sense? Angel expert Eileen Freeman says no. "I don't think Andy's paintings contain the energy he experienced, because angelic energy cannot be contained in anything material. They are by nature not of the material world. But nonetheless, our own recollection, our own interpretation of those experiences, can awaken the same things in ourselves and be transforming for us. . . . I believe it's Andy's interpretation of what happened, but that's very powerful, because what he experienced was powerful." ¶ From his first paintings, critics noted a primitive quality to Lakey's work, but even more than the simple lines and shapes, there is a primitive essence that echoes the art of our earliest ancestors. When primitive man drew a bison or a mammoth on the wall of his cave, he was not creating a picture for aesthetic purposes; he was trying to capture the spirit of the animal so that he and his clan might have greater success in the hunt. To the primitive mind, the act of drawing was a sacred gift, and one who could draw was considered holy, a shaman with power to heal and influence the course of earthly events. Drawing created a reality, an image, that allowed the clan to focus their belief. And that belief led to transformation—in the hunt and in the spirit. ¶ So too, with the angels of Andy Lakey. More than art to please the eye and soothe the soul, Andy Lakey's angels represent an attempt to call up the angelic energy and divine light that Lakey experienced in the other dimension. He is artist as shaman; and in the end, perhaps it doesn't matter whether he can truly capture that energy, that light, on the canvas, or whether he can only help others to make the discovery within themselves. What matters is that Lakey's art transforms the beholder. ¶

Floating Energy, *30" x 36", mixed media on wood, 1994.*

MY ANGEL'S ACTING UP!

An Interview with Christine Jade

After establishing a massage therapy practice in 1983, Christine Jade trained in Therapeutic Touch, Reiki techniques, and shaman work, before developing her own Myhija Energy Technique, which incorporates breath, sounds, and hand movements above the client's chakras—the primary energy centers in yogic philosophy. Then, in the fall of 1994, Jade discovered the paintings of Andy Lakey and added an unexpected dimension to her work as a healer.

In October 1994, Christine Jade and her fellow therapist, Lori Iverson, flew from Minnesota to Southern California for a class in Chinese medicine. Looking for an off-hour distraction, they decided to visit a store called Tara's Angels they had seen featured on television. "I had never heard of Andy Lakey," she says, "but when we went in the store and started looking around, I was drawn like a magnet to these paintings." Jade took one of the paintings off the wall and ran her fingers over the textured lines and shapes, feeling the powerful energy they expressed. She was so impressed that she returned to the store two days later; yet she left California without buying a painting.

Before her trip, Jade had bought a copy of Eileen Freeman's *Touched by Angels,* but she had never even looked at it. Shortly after returning to Minnesota, she opened the cover and found Lakey's *My Seven Angels* on the endpapers. After reading Andy's story, Jade contacted the artist and ordered an energy painting for her healing room, emphasizing that she wanted him "to put the energy into it for where it's going." As she waited for the result, she jokingly told friends and clients, "I know those angels are going to come right off the wall and help me," a prediction that turned out to be more accurate than she imagined.

As Jade first hung the painting in her healing room, she recalls, "tears just came to my eyes. I thought, What is it?" The next day, when a client arrived for an energy session, she began to find out. This particular client, Dee Dunn, is a highly educated, spiritually evolved woman for whom the healer has great respect, saying, "I think she should be working on me instead of me working on her." When Jade showed her the painting, Dee Dunn refused to let go of it:

"She said, 'I just can't put this down.' I said, 'Well, just get on the table and we'll lay it on you.' Dee held the painting on her stomach as we started the energy session, and I knew the session would be totally different from what it usually was. I held the painting above her chakras, and using breath, allowed her energy to flow. Dee felt her throat open. She said it felt like wind blowing through. She had energy opening occur in her heart center, too. She said she felt so peaceful after. I know that she had cell imprinting done, and her soul energy vibration was raised."

As soon as Dee left, Jade called Andy Lakey's assistant and left a message. "You have that man call me. My angel's acting up!" When they spoke Lakey asked her to keep a record of what happened with other clients as well. It was the beginning of a new and mysterious phase in Christine Jade's journey as a healer. During the following year, Jade obtained several other Lakey paintings, while many of her clients obtained paintings of their own. Incorporating the paintings in her Myhija Energy Technique, Christine Jade has documented a fascinating variety of healing responses on physical, emotional and spiritual levels.

Dana Steelman, who has been a quadriplegic since a 1985 auto accident, reported renewed feeling in many parts of her

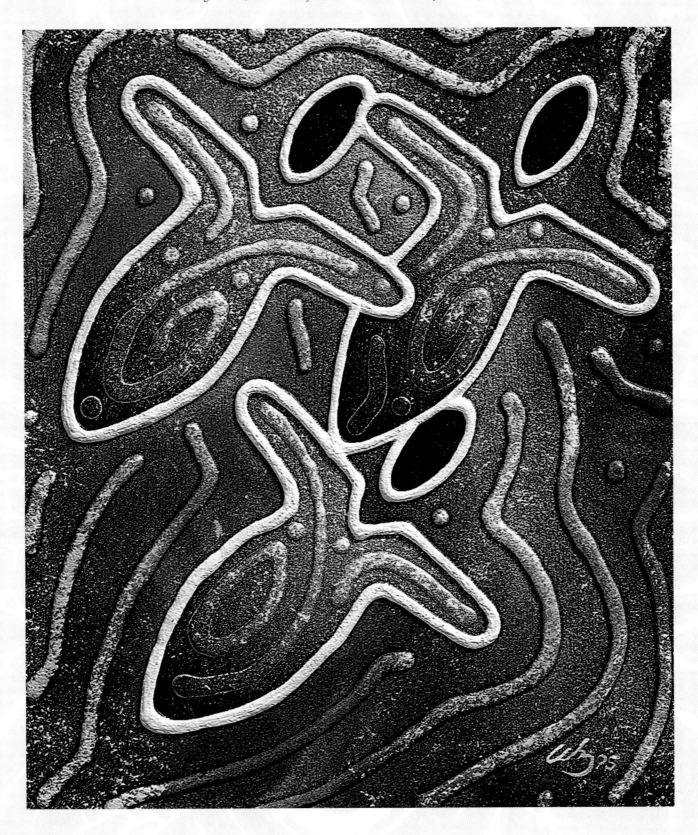

body that she had not been able to feel since the accident. She can sense her three middle fingers, her trunk, stomach, and buttocks, her legs, even the bottoms of her feet being tickled. "I feel like my whole body is starting to wake up," she says. Dana has also experienced deep and powerful visions of Jesus and her guardian angels, often while holding a Lakey painting. "Dana is physically bound," Jade explains, "but she can allow her mind to expand its consciousness and bring that information back to us who can get up and walk around. . . . What she's actually telling us is that there is more than just a body; that's only a small part of what we are about on this earth."

Dana Steelman offers the most dramatic of Christine Jade's healing experiences, but many other clients have reported similar energy while touching the Lakey paintings. Debbie Deckleman, who has suffered from extreme sensitivity to light, had a vision of two angels pouring healing water and was able to go outside without sunglasses for the first time in many years. Dianne Koball, who suffers from multiple sclerosis, said, "While holding the painting I felt an intense vibrating up to my elbows, with the sensation of voices coming from it."

One of Jade's friends, David A. Larson, has used a Lakey painting in his own practice as a licensed psychologist. "Although some clients appear to not notice it in my office," he wrote to the artist, "some are attracted immediately to it and are moved significantly. . . . The balancing effect is a miracle to me every time I witness it. One client has come in several times enraged at being sexually abused and leaves—floats, rather—out of the office after releasing her pain and absorbing the energy of the painting."

Clearly, these healing experiences reflect the abilities of Christine Jade and David Larson and the personal beliefs of their clients as much as the energy of the paintings. But both therapists are convinced that the paintings themselves contain healing energy, and they connect that energy specifically with the chakras. "I can't prove it scientifically," Jade admits, "but these paintings balance the chakras. I've dowsed over a person before using the painting and the chakras will be closed. I lay the painting on there for three or four minutes, and I dowse again, and they'll all be open."

Christine Jade has such faith in the power of Lakey's art that she carries a small painting with her whenever she travels. One such journey took her to the hospital bed of her five-year-old grandson, Adam, who was in intensive care following corrective heart surgery. Without saying a word, Jade simply set the painting at the foot of Adam's bed. A few weeks later, when he was back at home, Adam casually announced to his mother, "The angels were with me in the hospital." Upon further questioning, he told her that there were "four boys and four girls" wearing pink robes. "They came to see me," he insisted, "to visit me in the hospital."

The product of a child's imagination? Perhaps, but Jade doesn't think so. As remarkable as her experiences have been with adults, children seem to be even more sensitive to the power of the paintings. Five-year-old Becky Mundahl spoke with impressive conviction as she stroked the raised forms and energy patterns of a Lakey angel: "This is a real painting of real angels. Somebody very special knew that they were real and painted them."

WOW! THERE'S AN ENERGY!

An Interview with Shari Belafonte

When Shari Belafonte was offered a role as cohost of the syndicated show, Lifestyles of the Rich and Famous, *she agreed on one condition: that they drop the* Rich and Famous. *"I wanted to do more meaningful stories," she explains, "not the same old stuff about some celebrity who bought a palace from the Sultan of Brunei." The producers agreed to her request, and the show was rechristened* Lifestyles with Robin Leach and Shari Belafonte. *The mission of Andy Lakey turned out to be the kind of story she was looking for.*

Although she was genuinely intrigued by Andy Lakey's story, Shari Belafonte approached it like any other interview. Yet the moment she walked in the door of his home, which is filled with some of his finest angel paintings, she knew that this would not be a typical experience:

"Walking into Andy's house, I definitely got the impression that this is somebody who's been to another zone, another place. There is an otherness to Andy that I haven't really witnessed in the general public. I don't run into people everyday and say, 'Wow, you've been somewhere else!' I've had that feeling a few times in Native American villages and in other areas of the world . . . Africa, Japan. There is that spirituality, that sense of energy you get in those places. But I think this was the first time I felt that in somebody's home, somebody who wasn't a spiritual seer or a prophet. It wasn't even the art that affected me right away. . . . It's just this space you walk into and go, 'Wow! There's an energy!'"

After her first, powerful impression, Belafonte fell back into the mundane requirements of her job, what she laughingly calls the *chazerei* of the interview business. "Hello, how are you? I'm Shari. Pleased to meet you. Oh, these are lovely paintings. We're a production company. We're here to shoot you and then I'm outta

here, 'cause you're two hours away from everyone else I have to get back to." Once again, however, the art and otherness of Andy Lakey caught her by surprise:

"There was one moment when I wasn't talking to anybody; I was looking at the very large painting of the angels—the seven angels—and it was at that moment that I realized I'd seen those angels before. I'd seen that shape as a kid, when I was two or three years old. And that kind of zeroed me in, honed me in. 'All right, you're here now. Be here.' As opposed to getting ready to go interview whoever I was getting ready to go interview the next day."

As Andy Lakey told his story, Belafonte found herself absolutely fascinated, drawn in by his fresh honesty and the strange depth of his experience. For a time, she forgot her role as a "celebrity," forgot that she was Shari Belafonte, center stage, trying to meet the expectations of others. Instead, she did one of the things she does best: she listened. "He opened up from the heart," she remembers. "And when people are willing to talk to me from the heart . . . as opposed to stuff that's been fabricated to get your attention . . . it's a much more interesting story to listen to."

Later in the interview, Lakey placed a blindfold over Belafonte's eyes and invited her to experience *My Seven Angels* in a different way, through her sense of touch. Andy had told her that different colors had different textures, but she was skeptical. As long as she could actually see the painting, even as she ran her fingers across it, the different textures were too subtle for her to notice, as if she were "blinded" by her sense of sight. But when she covered her eyes, her sense of touch took charge, gaining new power that she had never imagined before:

"When I put on the blindfold and started touching the angel, I

remember hitting one point on the lines that was radically different, a radically different feeling. In terms of sight, it was only the difference between white and silver, and I would never have been able to hone in on that without really searching for it with my eyes open. However, not being able to see, my fingers went right to it, and I got it right away. I remember feeling this sensation up my arm, whoo-oo-oo, like a burst of energy. And I remember thinking, 'That's the difference . . . that's what's really special about this artist.'"

When Belafonte removed the blindfold and looked at the painting again, her entire face lit up with joy. It was a special moment on the show, the kind of moment that she had envisioned when she first began to look for more meaningful stories. "It was a whole different feeling. I saw it with new eyes because I had seen it through my fingers."

Having spent her life in and around the entertainment world, Shari Belafonte offers an interesting perspective on Lakey's appeal to celebrities, particularly those in show business. "The appeal is an honest story and an honest way of life that is not as apparent in what we do. Everything we do is make-believe. We do it well; we *make* you *believe* it," she says, emphasizing the words make and believe with just a hint of mischief. "It's endearing and enlightening to see one of those stories that we portray on TV in real life."

Shari Belafonte and Andy Lakey holding Angel #803 *at Lakey's studio, 1994.*

In a spring 1995 feature on "Artists in the 1990s," *Manhattan Arts International* magazine profiled Andy Lakey, praising him as an "artist and humanitarian [who] offers solace and inspiration." The magazine described his angels as "simple, universal and timeless forms emanating from ethereal energy fields . . . omnipotent messengers [who] soar on direct paths to higher realms, moving with steadfast precision. . . . Viewers feel the power of love, peace, hope and goodness radiating from the paintings." ❂ All true and beautifully expressed, but there is another reason why Andy Lakey is an artist of the 1990s: he is a man on a mission that spans the decade, a mission that began in the first days of 1990 and will draw to a close on the first day of the year 2000. ❂ In discussing the 1890s, social and artistic critics speak of *fin de siècle* spiritual malaise and dissipation, reflected most notably in the art of Henri de Toulouse-Lautrec. What will commentators say of the 1990s? There is malaise and dissipation, to be sure, but there is something else as well, a groundswell of spiritual renewal, a genuine desire among many of us to cure that malaise and reach for a higher and better vision of our world. The popularity of books like James Redfield's *The Celestine Prophecy* and Betty Eadie's *Embraced by the Light* points to the deep interest in spiritual exploration. And in the world of art, the work of Andy Lakey suggests that higher vision beyond the capacity of words. ❂ Lakey's more recent paintings explore new techniques and new variations on his angelic theme. To some extent, of course, he has done this from the beginning. His Celestial Style differs dramatically from his Angel 2000 Style, and one need only compare *Angel #1* and *Angel #1001* to see his development and growth during his first five years of painting the angels. Yet despite this evolution, the first half of Lakey's ten-year project seems to be marked primarily by steady movement toward the final goal, as he gained control and mastery over his technique and subject matter. If so, then 1994 and 1995, the middle years of the project, mark a point of departure, a new level of energy and exploration. ❂

CHAPTER SEVEN

Today, Tomorrow, & 2000

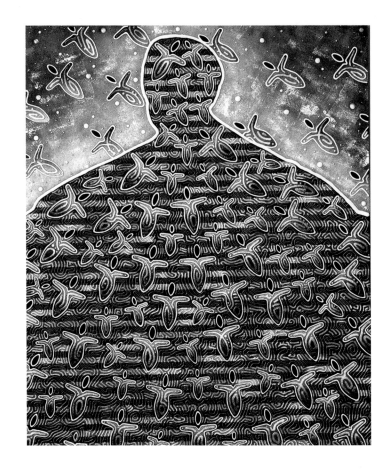

Angel #999, 6′ x 5′,
mixed media on wood, 1994.
Collection of Basuki Purnomo.

Like most changes, Lakey's was gradual, but if we choose a seminal work, it would be *Angel #999, Spirit Man*—a grand 6' x 5' panel in which the artist portrayed himself in exaggerated, outline form with hosts of angels flying within and beyond him. Completed in late 1994, *Spirit Man* probes the heart of Lakey's experience in a way that he never probed it before. Not only does the painting demonstrate more mature design and technical abilities, but for the first time since he began to paint, Andy Lakey—who actually frightened himself with the intensity of his early paintings—was psychologically prepared to portray himself and his angels together. "I guess I feel a little more distance now," he says today. "My near-death experience is still very real, but it's not as raw, not as jolting to my mind."

¶ In late 1995, Lakey explored a similar theme in a series of more intimate panels: *Angel #1370, Self Portrait #1; Angel #1371, Self Portrait #2;* and *Angel #1372, Self Portrait #3.* Here again, he is dealing with his experience from a more personal perspective: "In the self-portrait series, I'm trying to capture the actual millisecond when I left my body and was thrown into the other dimension. In the first self-portrait, I'm outlined in white, while in the second self-portrait, I'm outlined in gold. That's the last millisecond of life left before I go to the other dimension. Then the

Angel #1370, Self-portrait # 1, *8″ x 10″, acrylic on wood, 1995.*

third self-portrait is outlined in white again but there's no light inside the body—no life force—it's solid black. You'll notice, too, that the signature covers the entire body; that's the largest signature I've ever put on a painting in relation to the size. It's kind of a good-bye." ¶ Adding to the sense of leaving for another dimension, Lakey created the self-portraits in descending order of size, from 8" x 10" to 6" x 8" to 5" x 7". In a pair of much larger panels titled *Angel #1398, Primitive Man with Angels* and *Angel #1399, Modern Man with Angels,* he used a similar design to explore the connection of the human race and the angels, a relationship that he believes was as real fifty thousand years ago as it is today. ¶ Lakey's willingness to confront his experience head-on, to place himself and other human beings in the angelic dimension, has allowed him to move beyond the more stylized aspects of the Angel 2000 series and recapture elements of his Celestial Style. In a 6' x 5' panel, *Angel #1400, Purple Man with Angels,* he integrates the abstract extraterrestrial figure found in early works like *Green Man* with a mature, flowing treatment of the angel icon, while a powerful 1995 abstract titled *New World* integrates the parallel lines found in much of his celestial work with the iridescent colors of his more recent angel paintings. ¶ Lakey's increasing confidence and freedom of

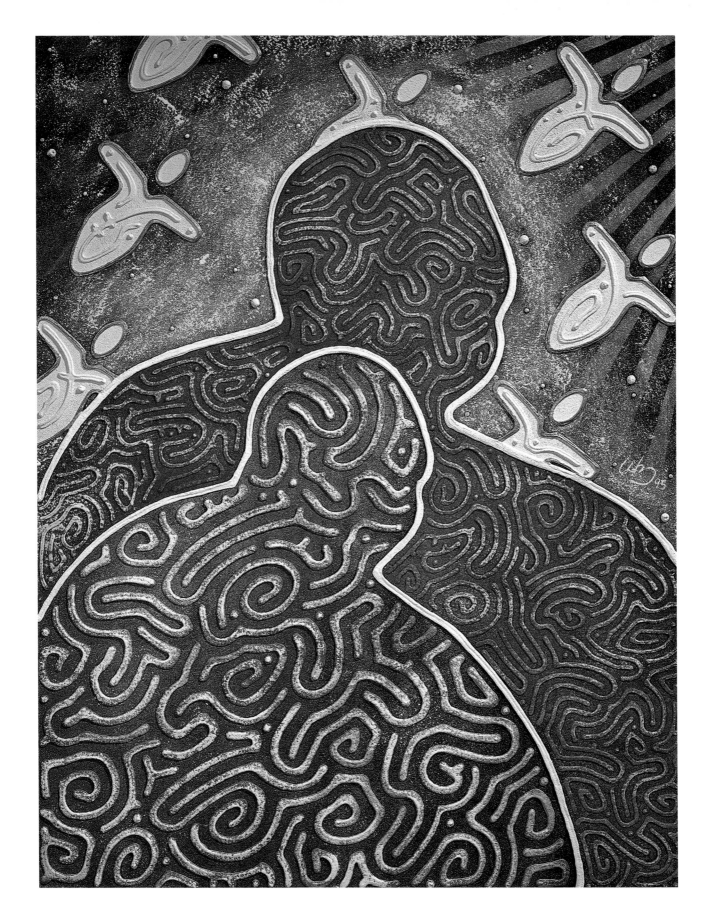

Angel #1398, Primitive Man with Angels, *36" x 48", acrylic on wood, 1995.*

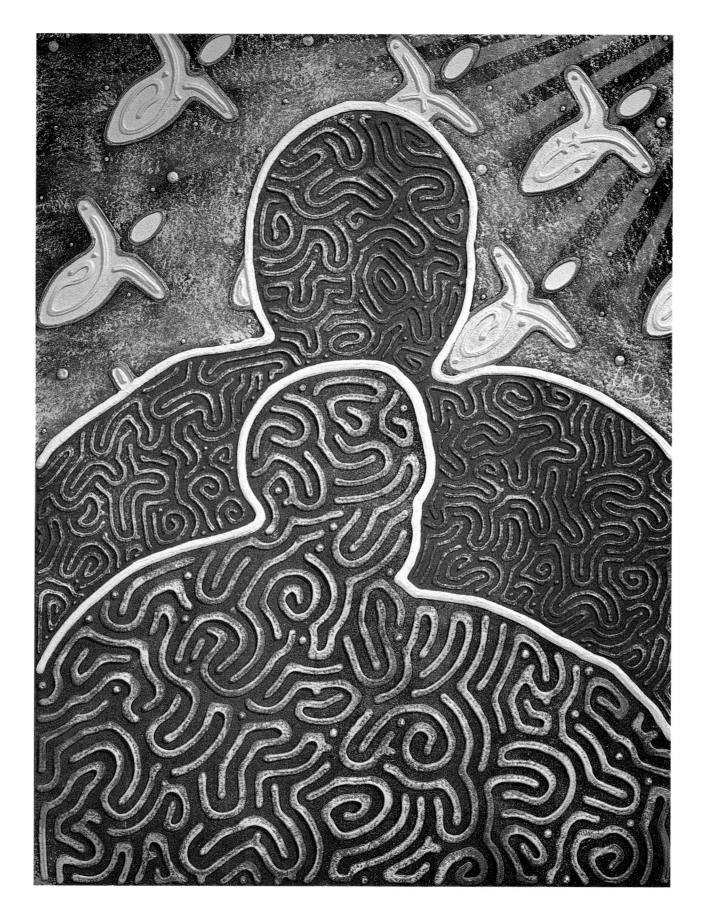

Angel #1399, Modern Man with Angels, *36″ x 48″, acrylic on wood, 1995.*

Left. Angel #1409, *10" x 12" x 10", acrylic on wood, 1995.*
Right: Angel #1410, *10" x 16" x 10", acrylic on wood, 1995.*
Collection of the Butler Institute of American Art.

expression has also taken him in myriad new directions, all pointing toward the future. Always intrigued with the physical foundations of his paintings, he has created arching, three-dimensional wall sculptures, as well as pyramids, diamonds, and cylinders with angels painted on the visible surfaces. He's even designed a large black box that the viewer must enter in order to see the paintings on the inside, taking his efforts to convey the reality of his original experience to yet another level. ¶ Lakey has been producing an incredible number of angel paintings, averaging almost one a day during the last two years, often working on twenty, thirty, even forty relatively small panels at a time. Now that he is clearly in reach of his goal, he looks forward to concentrating on larger panels for the rest of the decade, working more slowly on each and exploring new directions. Yet he believes that the intense, multi-panel production has been an essential experience, providing him greater insight into his own creative process. ¶ "When I have a blank board, I know in my mind exactly what it's going to look like. There may be a little color variation, a line may be different here or there, but essentially I see the painting before I begin. Now let's say there's a running river of water, and this running river is these thoughts of paintings—square paintings, angles doing this, lines and

Diptych: Angel #1379 *and* Angel #1380 *(left to right), each is 24″ x 44″, wall sculpture, acrylic on wood, 1995.*

patterns doing that—when I grab a board, and start to paint, I scoop the water. Those are the thoughts that I grab. That's why groups of paintings are very similar—though there are subtle differences. If I started a group of paintings the next day they'd be totally different." ¶ For Andy Lakey, the water of inspiration is a deep, wide river that flows from a source beyond this earth, a source that Lakey himself doesn't fully understand. Yet he feels the power of that source everyday, dipping into the water again and again in an act of transcendent creation. Will the water ever run dry? Lakey thinks not. "If I had the ability to create what's in my mind right now, what I see everyday and what I sketch everyday, I would need a million lifetimes to create one day's work. It's like pictures constantly flashing in my mind. I would like to create as many paintings as I can in my lifetime, but that wouldn't be enough. It wouldn't even equal a day's worth of thoughts." ¶ When Lakey speaks of a day's worth of thoughts, he is referring to artistic thoughts of image and design, of angels flowing across a painted panel. What of thoughts behind the paintings, behind the angels, the textured lines and patterns? What is the message of Andy Lakey's mission? Even as he strives to express it in his art, Lakey admits that the underlying meaning is difficult to understand, ineffable perhaps,

Art chair, front view, mixed media, 1995.

Art chair, rear view, mixed media, 1995.

because it arises from an infinite and ineffable source. But he has a few ideas: "I think a lot of people are being touched and feeling comfort. That's what I felt during my experience in the ball of light. Those three men, those three angels, were like three fathers of mine who really loved and cared about me. I felt the love; I felt so protected. And I think their conveying that love and that comfort to me was a way for me to convey the same feelings to other people. They wanted me to do a job that they couldn't complete themselves. Why couldn't they do it themselves? Why did they need me? I don't know, but I've thought about it a lot. ¶ Maybe they were my three angels, and I was assigned to them at birth, or maybe these three angels were assigned to a dozen people or a hundred people or a thousand people, but they weren't in charge. My original experience took me all over the universe, so it's possible that I saw some things they had never seen themselves. Or it could be that these three men oversee the whole world. Maybe they're everybody's angels. I just don't know; I can't give you those answers. But let's imagine there are thirty thousand of these angels for planet Earth, just as there are other angels working on planets in other galaxies. They can't control the big picture, but maybe they can plant a couple of little seeds to show God that they're trying to do their thing, to help us, so they can move on to their own next level. And maybe I'm one of the seeds they planted." ¶ That Andy Lakey is one of our most prolific painters seems unquestioned; that he is on the road to becoming one of the most popular painters seems likely. Will he be considered one of the great painters? Only time will tell, and

New World, *24″ x 24″, acrylic on wood, 1995.*

Lakey has plenty of time. Thirty years old when he began to paint, he'll be forty when he completes Angel 2000 on New Year's Eve 1999, finishing the final angel at the stroke of midnight among a gathering of collectors. What will he do then? What happens when the mission is over? Lakey doesn't know. He'll keep painting, but beyond that he believes the potential for himself and for all of us is limited only by our imaginations. ❡ "In the year 2000 or the year 3000, who knows what will happen? Man has been advancing very slowly for a long, long time. I can't give you the exact figures, but let's say it took us a million years to develop fire, a million more to develop tools, tens of thousands more to develop farming and electricity. Now we're moving quickly, and collectively, all of us—the human race—are going to get together someday. I think we're actually going to leave this planet and do some remarkable things. ❡ You and I won't know what will happen, just like Columbus didn't know that we would have cellular phones some day. Can you imagine a thousand years from now or two thousand years from now? Who knows where this whole thing is going? I think that every one of us somehow—and everyone who's been here before—is an ingredient to where we're ultimately supposed to go. I don't have the answer; I'm just doing what I was instructed to do. The angels are my teachers, my guardians. They wanted me to do it, and I'm going to do it. ❡ I love to paint, but I believe that the paintings are a means to a higher goal. I hope that I can help save some lives, change some lives for the better, especially children. I want to help build hospitals and continue to work with charities. I plan to share my artistic technique with artists from other countries, so they can express their own themes in touchable, durable art. And maybe those artists will contribute to their own charities and help their own people. I don't have a crystal ball, but I really feel that this is just the beginning. I think that, in my own small way, I'm going to impact this planet somehow." ❡ Some would say he already has. ❡

The artist at work, 1995.

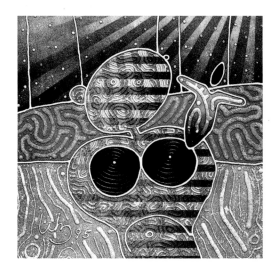

Transcending #1, *24″ x 24″, acrylic on wood, 1995.*

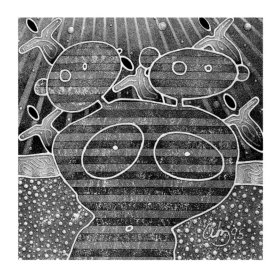

Transcending #2, *24″ x 24″, acrylic on wood, 1995.*

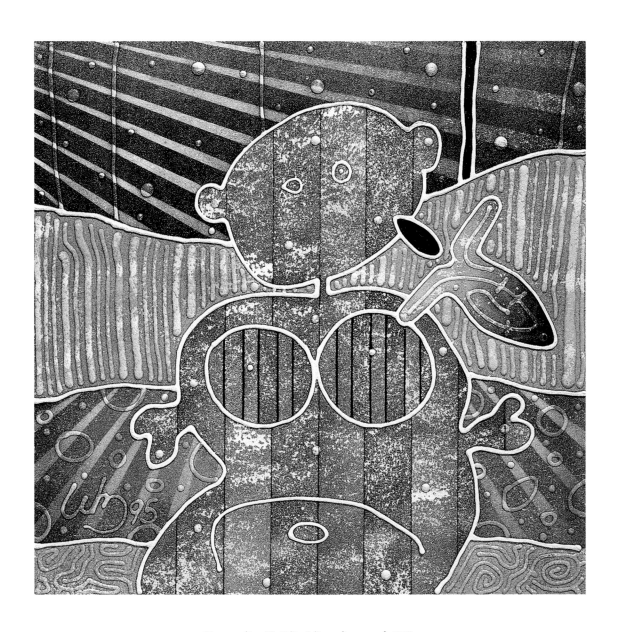

Transcending #3, *24″ x 24″, acrylic on wood, 1995.*

ANGELS FOR THE ANIMALS

At the Broadway Animal Hospital in El Cajon, California, Dr. Richard Johnson and his wife, Dr. Nancy Hampel, work to assure the health and well-being of their client's pets. But sometimes an animal is beyond their power to heal, and the veterinarians must take on a sad but necessary responsibility. They have to put the animal to sleep.

"We deal with death all the time," Dr. Johnson explains. "My clients are constantly asking me, 'Where do animals go? What do you think? Do they have a soul? Is there an afterlife for animals?'"

Dr. Johnson can't offer a definite answer to his clients' questions. No one can. Yet he believes that there is a higher purpose to animals, and he likes to think that they go to a better place. His real concern, however, is not these theological issues, but rather to comfort his clients who lose their beloved pets.

One night, Johnson happened to see *Angels, the Mysterious Messengers* on television. At the end of the segment on Andy Lakey, there was a brief mention that the artist had begun to do some paintings of animals for children. The veterinarian was intrigued.

He contacted Lakey through the show's producers, and when the two men spoke on the telephone, the first question Johnson asked was, "What's the relationship between animals and angels?"

Lakey laughed. "I don't know," he said. He hadn't thought much about a connection between animals and angels. His animal paintings—though they contained hidden angels—were really another direction he was pursuing with his art, an attempt to create something special for children, especially blind children, who could feel the forms of the animals they couldn't see. When Johnson asked Lakey to create a painting for his animal hospital, the artist replied that he was too busy to take on a commission at that time. He referred the veterinarian to one of his dealers, who sent photos of several Lakey animal paintings. But they weren't what Dr. Johnson had in mind. He was determined that Andy

Angel #1300, *132" x 48", acrylic on wood, 1995. Collection of Dr. Richard Johnson.*

Lakey should create something very special for his hospital.

In the meantime, fate—or the angels—intervened. One day, Andy's wife, Chantal, was talking to her best friend, Brenda Holland. Chantal happened to mention that Andy was so busy he had recently turned down a commission from a veterinarian named Dr. Johnson. Brenda lit up immediately. She knew Dr. Johnson well and was impressed with the quality of care at the Broadway Animal Hospital. She was convinced that Andy should do the painting.

Pressured by Brenda and Chantal, Lakey finally agreed to visit the animal hospital and meet Dr. Johnson. For the first time, he began to understand the real possibilities of the project. Johnson didn't want a nice, little animal painting; he wanted a very large painting of animals with angels looking over them. A whole wall in the hospital was just waiting for the art. "He filled it all," Johnson says with a smile. "The painting ended up being eleven feet long and four feet wide!" It was the largest painting Lakey had ever created.

Since it was first hung on the wall in January 1995, the painting has done exactly what the veterinarians had hoped it would do, providing a sense of peace and solace to clients who must have their pets put to sleep. It has inspired joyful comments from countless other clients, as well, and it's a special magnet for children. They smile with delight when they see it and love to run their fingers along the outlines of the brightly colored animals.

Do animals really have angels to watch over them? What *is* the connection between animals and angels, anyway? On the wall of the Broadway Animal Hospital, Doctors Richard Johnson and Nancy Hampel express their own feelings in an eloquent plaque beside the painting:

"As veterinarians, we have had a lifelong feeling that animals represent the good in people. They are not only protected by the angels but serve as guardian angels of their human families.

"Andy Lakey has shared these feelings and has generously agreed to create this original painting to express the joy and innocence of our animal family. We feel it is an extension of Andy's angels with their protective love and beauty to the animal world."

Andy Lakey shares his touchable art with students at a public school in San Diego, California, 1991.

SEVEN LESSONS

by Andy Lakey

The events of my life have taught me to look at the world very differently than I did before. The truth is that I am a different person—and I believe, a better person—than I was before I met my angels. I would like to pass along seven lessons I've learned in the hope that they will be as helpful to others as they have been to me.

Lesson #1: Love and Compassion. I never felt a lot of love as a child, and before my experience I had a hard time feeling love for others. When I met my angels, I experienced a deep, unconditional love, and my attitude changed. Now I look for the good in people, and I feel love and compassion for others wherever I go. My wife, Chantal, has taught me a lot about love, too, and about commitment between two people and the love we create in our family. Unconditional love is selfless, fearless, and continually expanding. It's a well that never runs dry. Most importantly, treat yourself with love. Once you love yourself and you love others, it's as if the world knows this, and the world will take care of you and give you love back. Love is the strongest force in the universe.

Lesson #2: The Power of Prayer. I didn't realize the power of prayer until New Year's Eve 1986. Since then, I've prayed every day to God, to the angels, to the universal energy. For me, the most effective prayer is to ask for what I need and then give thanks for the help I will receive. I believe that when you pray, when you put it out there, you're creating action in the universe. I know that prayer will always be answered in one way or the other. At times prayers are answered immediately—as when I felt I was dying—and at other times, patience is essential. If you wait, the answer will always come, sometimes when you least expect it and in the most unusual ways.

Lesson #3: Words Have Wings. Prayers are special words or thoughts that we send to a higher power, but every word we say, every thought we think, goes out into the universe and creates action. When I met Chantal, she taught me a saying: "Words have wings; don't say those things." We should not say negative things, because negative statements lead to negative results. As soon as you say, "I can't," you've already taken a giant step toward failure. At the same time, positive statements—affirmations—lead to positive results: "Words have wings; say good things." I make affirmations every day, and I don't even consider the possibility of failure. After my experience, I began to keep a diary in which I wrote down some predictions for my personal future, things that I wanted to happen. Some of them might have seemed outrageous to other people, but almost every one of those predictions has come true.

Lesson #4: Visualization. Just as words and thoughts have power, so do images. I have discovered this through my art, but I also create images in my mind. When you visualize an event or situation, you are actually establishing a new reality in the universe. Let's face it: no matter how positive we are ourselves, there is plenty of negative energy coming in from other people, other beings, maybe even other galaxies. So I visualize bubbles of love and protection around myself, my family, and other special people in my life. For example, every night, when I put my two little girls to bed, I visualize them sleeping soundly and peacefully inside a bubble that will prevent any negativity from touching them. I also visualize positive energy entering the bubble and giving them pleasant dreams and a restful sleep. You can put bubbles around anyone or anything.

Lesson #5: There Are No Coincidences. Life is a wondrous, complex journey, full of opportunity and meaning. Yet, every time something unusual happens, skeptics will say, "It's just a coincidence." I don't believe that. Everything that happens happens for a reason. Every so-called coincidence is actually a message from the universe, a form of guidance, an opportunity to grow as a human being and take another step along the path. It's up to us to see the meaning and act on the opportunity. It's also up to us to create opportunities—to create situations where a life-changing "coincidence" can occur. Early in my career, a wealthy art collector happened to walk into a bank and see my paintings just a few hours after I hung them. A coincidence? Of course not. He was supposed to walk in and see those paintings. But if I didn't act on my impulse to hang the paintings in the bank, he never would have seen them. Listen to your inner voice, and look for the meaning in unexplained events.

Lesson #6: Giving. I have a saying, "The more you give, the more you get, the more you have to give." The universe is abundant, but many of us are afraid to give of ourselves, our time, and our resources. I can understand that, because it's not easy to make a living or do all the things we have to do every day. But I've discovered that giving actually creates more resources and more happiness, not only for the receiver but for the giver as well. When I first started painting, I often gave away my work—even though I wasn't earning much at the time—just to get the art out in the world. Needless to say, I've been repaid a thousandfold. Today I have a more organized program, donating about 30 percent of everything I create, and I get such a deep sense of satisfaction from seeing my work help others. Obviously I'm in an unusual position; not everyone can give away 30 percent of what they create or earn. But all of us can give more.

Lesson #7: Live in the Moment. Since my near-death experience, I look at every day as a special gift from God. I try to find the good in everything and savor each moment. Sure, I plan for the future, but I don't live in it, and I forget the defeats of yesterday as well. I live in the now, as if each day is my last. I appreciate the little things, because they're all part of the cosmic plan. When I look up at the night sky, I see the stars totally differently than I saw them before my experience. They're not just pretty twinkling lights; they're a reminder of what's really out there. In my heart and spirit I see bright planets and poles of light. I see angels flying through the universe, doing the work of God. Whether we know it or not, all this is happening all the time. Every day, every moment, is a great, cosmic adventure. Enjoy it.

The artist in his studio.

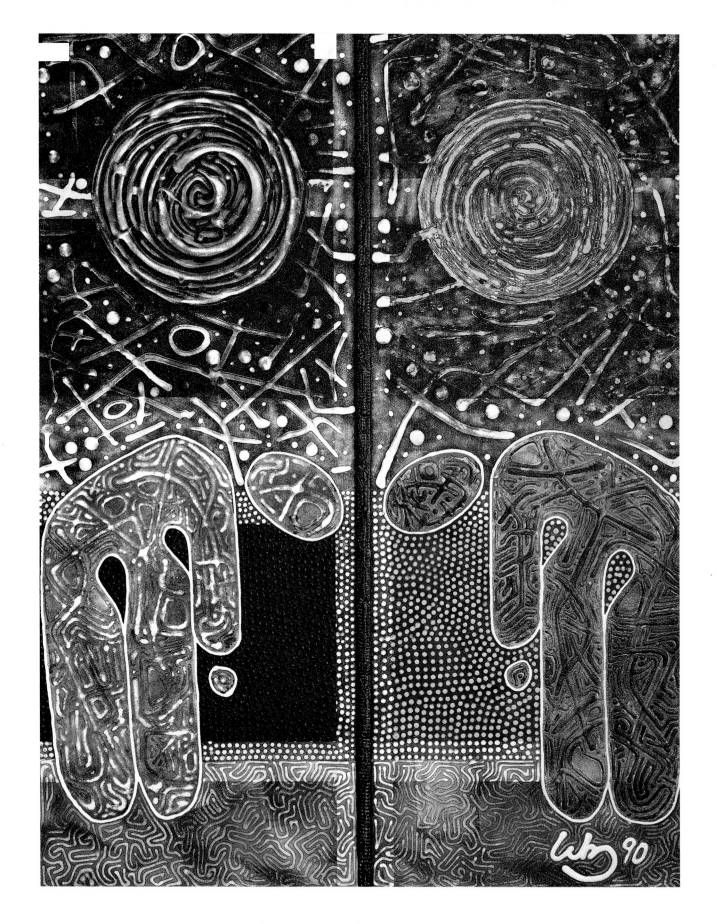

Holocaust, *36" x 48", acrylic on canvas over wood, 1990.*

ABOUT THE AUTHORS

Andy Lakey is one of the most famous living painters of angels in the world. His unique art form, meant to be touched as well as seen, reflects his own encounters with angelic powers. Lakey's life and work has been featured on many television shows and in national publications, including the *Oprah Winfrey Show*, CNN News, *Lifestyles*, the NBC documentary *Angels, the Mysterious Messengers*, and *Life* magazine. Lakey lives with his wife and children in Murrieta, California.

Paul Robert Walker has written fifteen books, including his recent collection of real-life moments, *Every Day's a Miracle*, in which he briefly tells the stories of Andy and Chantal Lakey. Walker's work has been honored by the National Council for the Social Studies and the Children's Book Council, the American Folklore Society, and *American Bookseller*. He is a member of the Authors Guild, PEN Center West, and the Society of Children's Book Writers and Illustrators. Walker lives with his wife and children in Escondido, California.

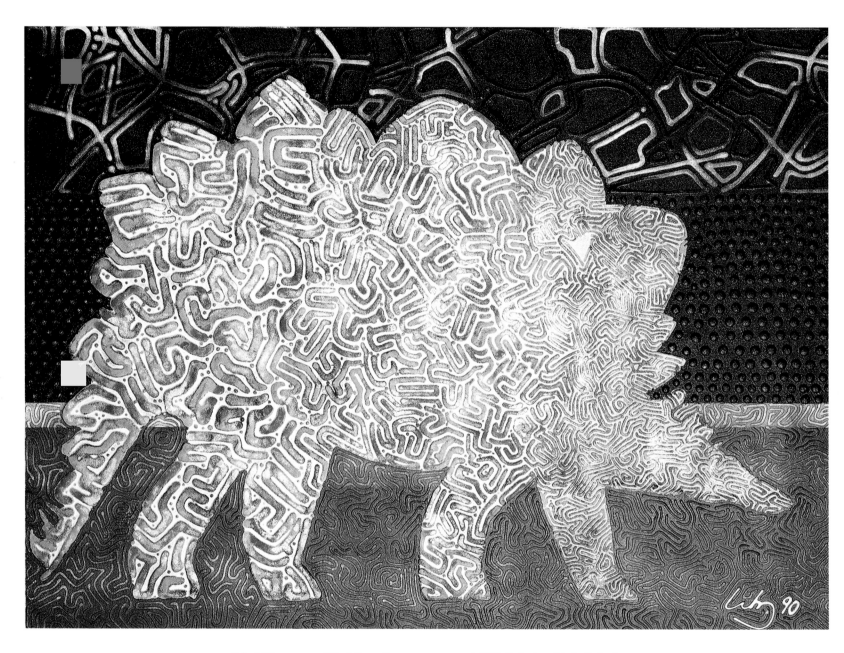

Celestial Stegosaurus, *48" x 36", acrylic on canvas over wood, 1990. Collection of the Leslie family.*